OFF GRID LIFE

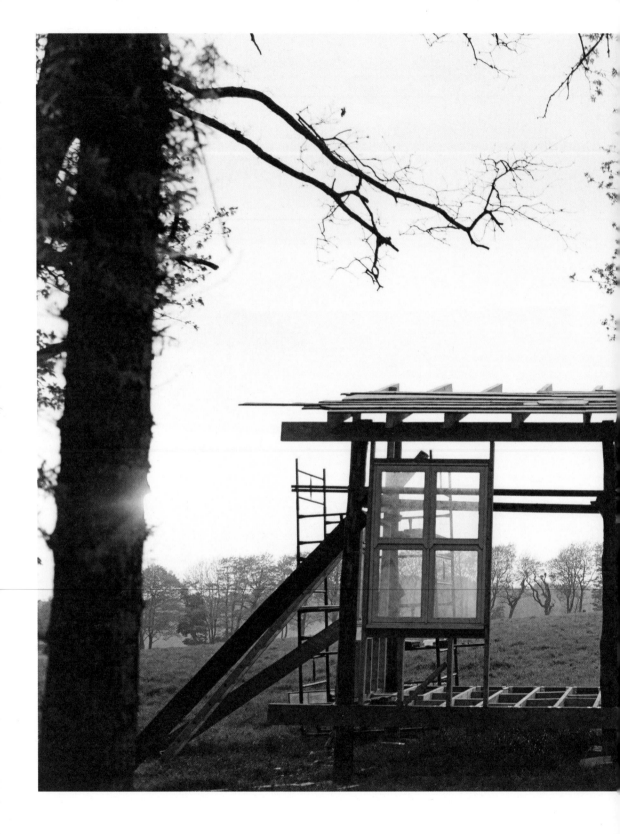

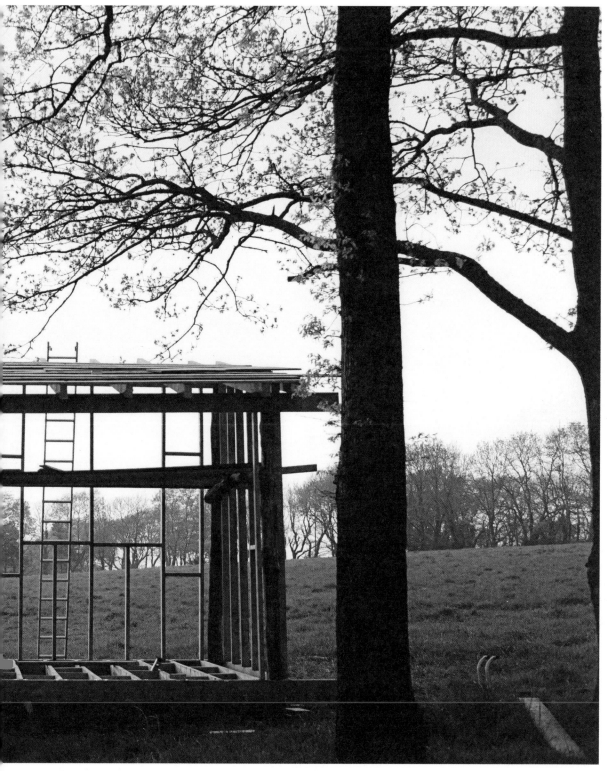

Samuel Glazebrook

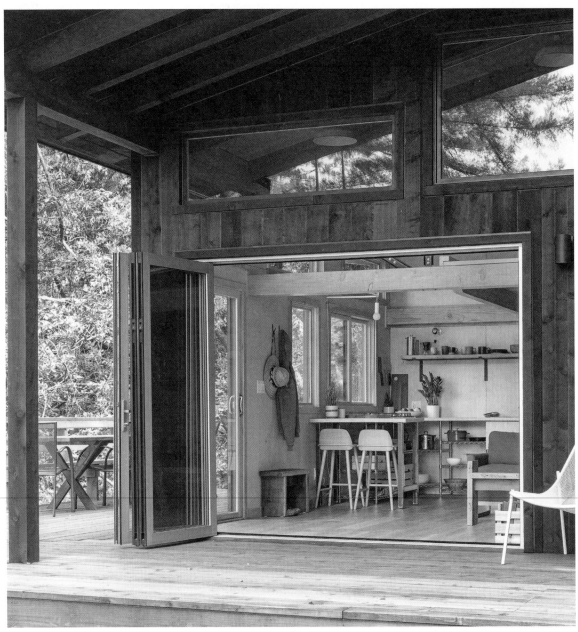

Jeff Waldman | California coast

OFF GRID LIFE

YOUR IDEAL HOME
IN THE MIDDLE OF NOWHERE

FOSTER HUNTINGTON

BLACK DOG
& LEVENTHAL
PUBLISHERS
NEW YORK

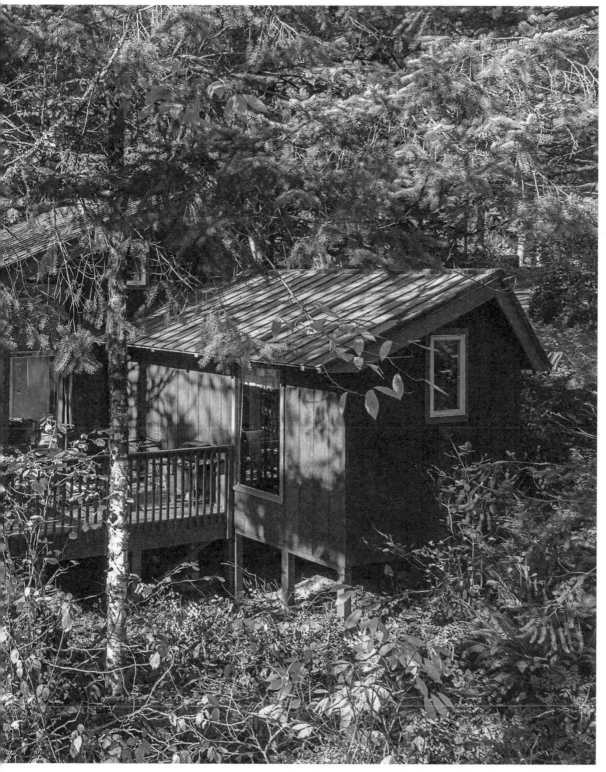

Dan Huntington | Columbia River Gorge, Washington

Black Dog & Leventhal Publishers
Hachette Book Group
1290 Avenue of the Americas
New York, NY 10104

www.hachettebookgroup.com
www.blackdogandleventhal.com

First Edition: October 2020

Black Dog & Leventhal Publishers is an imprint of Perseus Books, LLC,
a subsidiary of Hachette Book Group, Inc. The Black Dog & Leventhal Publishers
name and logo are trademarks of Hachette Book Group, Inc.

The publisher is not responsible for websites (or their content) that are not owned by the publisher.

The Hachette Speakers Bureau provides a wide range of authors for speaking events.
To find out more, go to www.HachetteSpeakersBureau.com or call (866) 376-6591.

Additional copyright/credits information is on page 217.

Print book interior design by Joshua McDonnell.

LCCN: 2019059241

ISBNs: 978-0-7624-9791-1 (paper over board), 978-0-7624-9792-8 (ebook)

Printed in China

1010

10 9 8 7 6 5 4 3 2 1

CONTENTS

Philipp Sacher | Germany

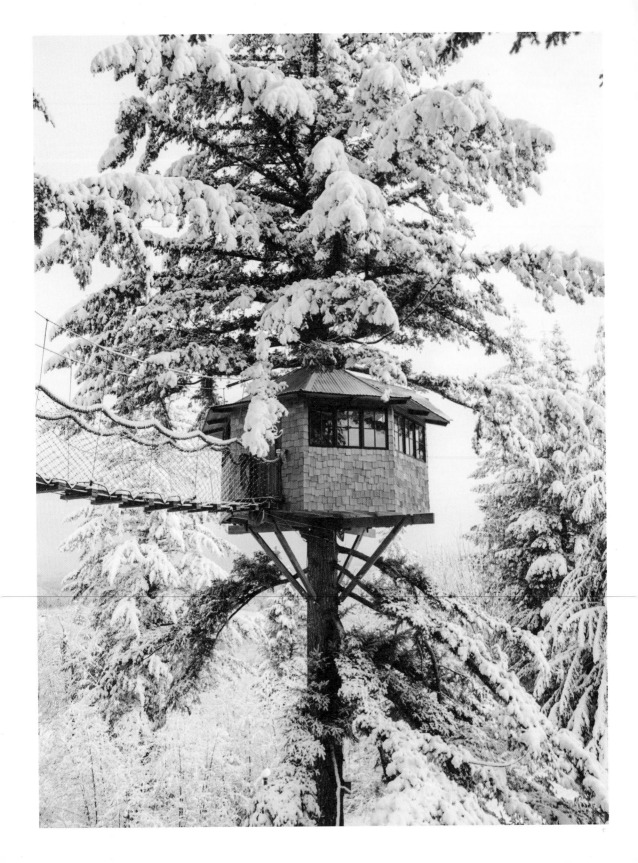

PREFACE

My foray into the realm of alternative dwellings moved from abstract day-dreams to reality in August of 2011. I left my fifth-floor walk-up apartment in Manhattan at five in the morning carrying my last possessions—two duffel bags, a surfboard bag, and a large Osprey backpack—and headed to LaGuardia Airport to catch a flight to Reno, Nevada, where I picked up a 1987 VW Vanagon Syncro. Over the next three years, I logged 150,000 miles driving around Mexico, Canada, and the western United States—living first in the Vanagon and then in a Toyota pickup-based camper. I parked at night on public land, in friends' driveways, and on city streets. I used bathrooms in coffee shops, restaurants, and truck stops. My vehicle was my bedroom and the outdoors was my living room. This period in my mid-twenties completely changed my expectations regarding what I needed to live comfortably, and what compromises I needed to make in order to be happy. It helped satisfy my thirst for excitement and confirmed my strong belief that there is more to life than a corporate nine-to-five.

Along the road I met people living in all sorts of different ways: in tents packed on the back of their motorcycles; in rustic cabins at 10,000 feet in the Colorado Rockies; in Airstreams in the hills above Los Angeles; and in treehouse colonies overlooking fields of marijuana in southern Oregon. The thread that tied it all together was that they all—some by choice and some by circumstance—lived in small homes they either built or actively maintained themselves, with self-taught know-how and their own hands. None of these houses had three bedrooms, two baths, and a garage. They were way below the average size, and most were less than 1,000 square feet.

After three years of living out of my vehicle full-time, I started pondering my next home. I looked at houses in Portland, Oregon, but quickly realized I had no reason to live in a city beyond the convenience of coffee shops, restaurants, and grocery stores. My ideal home wasn't surrounded by neighbors in a city dead set on matching the gentrification of the Bay Area and Brooklyn. I wanted a place with the infrastructure to allow me to undertake

larger projects—building, photography, filmmaking, etc.—and enough space to host all the friends that had been so accommodating to me on my travels. I wanted chickens, goats, and a garden. I wanted to have bonfires and cook over coals. I wanted to be able to pee outside without risking locking eyes with a neighbor midstream. I didn't want to take on a mortgage that would force me to work jobs I didn't want to work. I decided to look in rural areas, places a little more off the beaten path. I started brainstorming with my longtime friend, Tucker Gorman (featured in this book in both the Treehouses and Tiny Homes chapters), and we hatched a plan to build a series of treehouses and bridges in a cluster of Douglas fir trees on the top of a small dormant volcano overlooking the Columbia River Gorge.

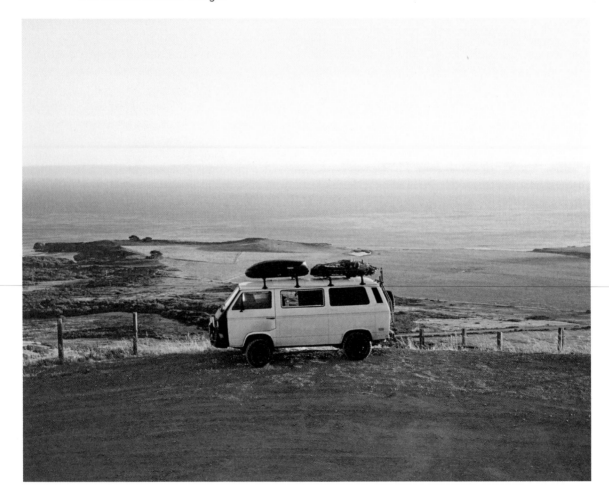

We built the treehouses—an adventure described in more detail in the chapter on treehouses—and I lived in them from 2014 to 2019. They didn't have running water or bathrooms, but since I'd been living in my car, it was a relatively easy transition. Using the treehouses as my bedroom and office, I lived, year round, 20 feet off the ground in a 200-square-foot space. I learned to tell what the weather was doing by the sounds the treehouses and bridges made. I dreaded the annual ice storms that coat my beloved Douglas fir trees in inches of ice. I refused to retreat to the ground during these stormy nights. I weathered falling tree limbs, shattering ice, and rocking trees with the same stubbornness as Ahab chasing the white whale. I noted the end of winter with the arrival of the tree swallows in April. Flying around the treehouses and below the bridges, chasing bugs and nesting in the trees, their coming always reminded me that we shared the same trees as our home.

As my mid-twenties moved on into my early thirties, my living needs changed again. My girlfriend, Kaycee, moved in with me, and we got a cocker spaniel puppy, Gemma. The treehouse started showing its limitations. Kaycee did not seem to enjoy peeing off the edge of the deck in the middle of the night the same way I did. There is a 1,000-square-foot converted barn home up at the Cinder Cone—the nickname of my property up in the Columbia River Gorge—about 200 feet from my treehouses. We started spending more nights on the ground and fewer in the trees.

These new presences in my life contributed to my evolving understanding of living spaces. When we travel in my van, Gemma actively seeks out the small storage cubby under the bed. She prefers to sleep there rather than on the mattress with the down comforter and pillows. When we are up at the Cinder Cone, Kaycee often chooses to sleep in a small loft or in the van instead of the queen-sized bed in our large bedroom. I see a pattern in their choices. Small spaces offer a sense of security and coziness that is very comforting. Over the course of human and mammal development, we've only been living in large, one-family houses for a very short time, about two hundred years.

Today more than ever, small homes offer young people an opportunity to have a house of their own. Statistics on home ownership among millennials are bleak. We are on track to be the first American generation less well-off than our parents. With more and more people working for themselves or as free-lancers in the gig economy, fewer and fewer of us will ever be eligible for home

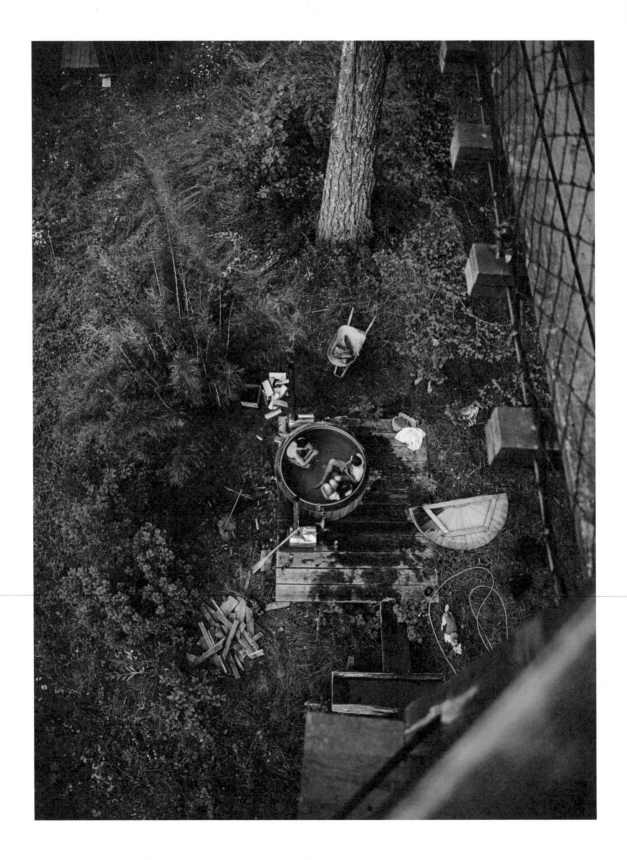

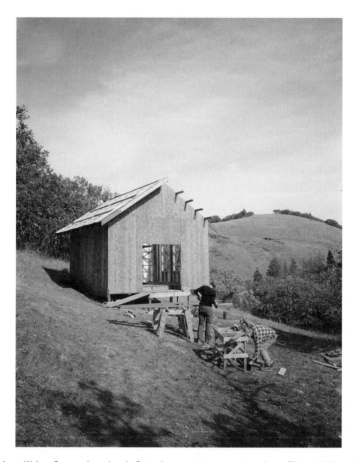

loans. We will be forced to look for alternative ways to live. This will be difficult because so many of us have lost all connection with our immediate environments. We no longer have the ability to make things or take care of our lives. Our food comes from hundreds if not thousands of miles away; it is delivered pre-prepared to our doors or to our local grocery store. For better or worse, we don't take care of our health on a personal level: if we get sick, we go to the doctor. When things break in our cars and homes, we pay professionals to fix them. No wonder people feel more depressed and helpless than ever before.

Of all the ways we can take control of our lives, getting involved in our shelter is one of the easiest and most accessible. The last forty years have seen an enormous transition from rural to urban areas, driving up property prices in cities to unheard-of levels. In San Francisco, for example, the average rent for a one-bedroom apartment in October 2019 was $3,600, according to Rent Jungle (www.rentjungle.com/average-rent-in-san-francisco-rent-trends). If we accept the conventional wisdom that a third of one's disposable income

should go toward housing, it would take a salary of well over a hundred thousand dollars a year to live comfortably in San Francisco. Major cities all over the country—L.A., New York, Seattle, D.C.—are becoming increasingly unaffordable for the vast majority of people. Those living in desirable smaller cities like Portland and Asheville are feeling the pressure, too. Conversely, rent and property prices in rural areas across the country have stagnated or declined.

As population numbers and property values in rural areas go down, the spread of the internet is creating more and more opportunities for remote work. My hope for this book is to inspire people to leave cities and move to these areas and find a piece of land. Start with something small. Build a yurt, put down a shipping container, or level off a space for a tiny house. Plant a garden. Invite friends out for a weekend. Build a wood-fired hot tub. Create memories building a structure with your friends and loved ones. Get your hands dirty.

The structures in this book, without exception, were all built outside of the

traditional home financing system and could never be purchased with a traditional loan. They were built with cash, either in quick sprints or slowly, as money allowed. The total prices range from as little as ten thousand up to hundreds of thousands of dollars. The common feature of the structures is that they were built with passionate and relentless work by people like you and me.

Nothing is without compromise. These structures all required some kind of compromise on the lifestyle many of us are used to—geographic compromises, size compromises, comfort compromises—but with these compromises comes the ability to live more economically, to make things ourselves, and to experience the natural world as more than something we watch on Netflix or scroll past on Instagram. My hope is that somewhere in the following pages, you will come across a building style or structure that plants a seed in your brain—a seed that ultimately grows into a home or retreat you can share with your friends and family.

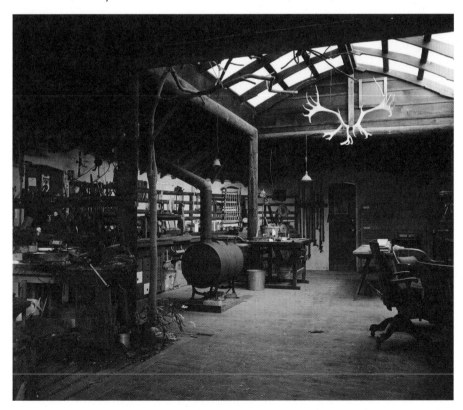

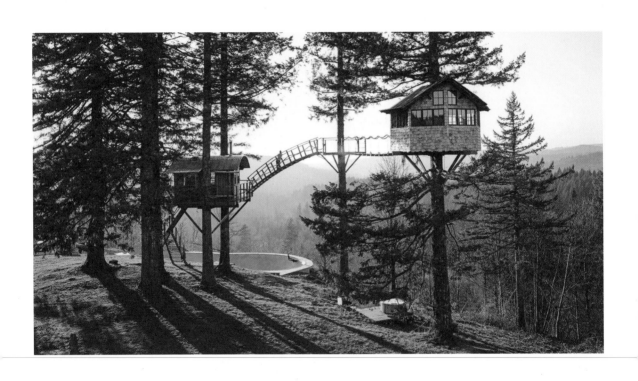

INTRODUCTION

Small Structures 101 with Lloyd Khan—
Perspectives from the Guru

If it weren't for Lloyd Khan and his books, I would never have gone down the path I have, nor live how I do today. For anyone unfamiliar with his work, Lloyd is a builder, writer, and owner of the independent publishing house Shelter Publications (shelterpub.com). Since the sixties, he's released over two dozen books covering topics ranging from geodesic domes to septic systems to physical stretching—but he is best known for books like *Shelter* and *Builders of the Pacific Coast*, which document wild and beautiful homes from all around the world. My parents always had Lloyd's books around the house when I was a kid. I remember flipping through them, captivated by the beautiful structures and carpentry. Whenever I'm making decisions about shelter, I go back to them for inspiration. I looked through them when we were building the treehouses, when I put the hot tub together, even when I was trying to decide what kind of car to live in. When I started working on this book, one of the first things I did was email Lloyd to ask if he was willing to be in it. He said yes, so like Luke Skywalker traveling to the Dagobah system in search of guidance and input, I headed down to Bolinas, California, to interview him.

—FOSTER HUNTINGTON

Lloyd Khan is an author, publisher, and builder.
He lives in Marin County, California, in a
house he built by hand in the 1970s.

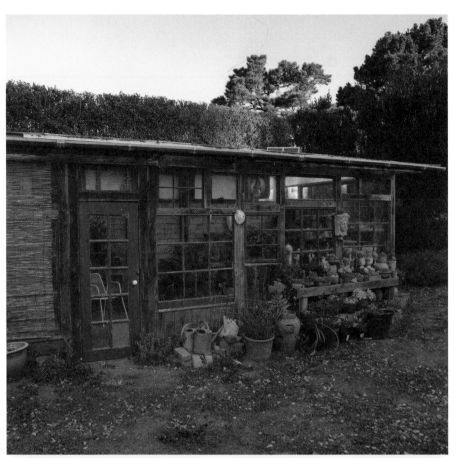

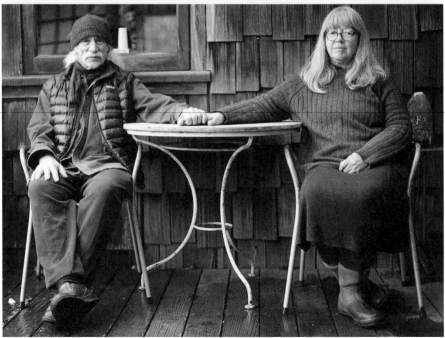

When I started building houses back in the sixties and seventies, we had a lot of time to fool around with different ideas, because you could live on so little back then. Land was cheap. Materials were cheap. It was easy to get together enough money to buy a little plot somewhere and start building. So we tried all sorts of different approaches.

Early on, I was a big advocate of geodesic domes. Everybody was excited about them back then—they were the icon of building for the counterculture. I spent five years building domes and released two books about them. When we did *Dome Book 2*, we rented a resort in the mountains near Santa Barbara for a month. We all went out there, we took our production equipment, the IBM composer for typesetting, the Polaroid for shooting, all of that. Maybe six or seven of us went out and spent a month working on the book.

Problem was, I had already started having reservations about domes. As we were driving out to the resort to start the project, we were passing these farm buildings. I was looking at them and thinking: those there are vertical walls, and then on top of them is a roof that's just a single plane. That's it. It was so simple. And here we were fucking around with triangles, putting them together, trying to waterproof them. And then, once you're inside a dome, you have all these angles going on that end up being a nightmare. A bed, a refrigerator, a chest of drawers—any of the normal stuff you put in a house is made up of vertical lines. They're rectangles. If you try to fit those rectangles into a dome, you've got problems. If you try to subdivide the dome into smaller spaces, you've got problems. If you try to add new spaces onto the dome later, you've got problems.

Say you want to do something that would be really basic and simple in a standard home, like put in a partition. So you have this vertical line, and when it gets over to the wall or reaches the ceiling, you have all these different angles you have to tie into. And if you want to add onto the dome, you have to do the same thing, you have to tie into all these different angles.

There are some good things about domes. They're easy for people to visualize. Anybody can look at a dome plan and say, "I understand that." And they're fun to put together. I can still see them working as studios or certain kinds of outbuildings, but not as homes. And I think one thing that really proves this is they just haven't caught on.

When I gave up on domes, it really pissed some people off. I remember there was a big conference in Los Angeles around 1970. Buckminster Fuller,

Paolo Soleri, a lot of big names were there. I went to do a presentation and everybody expected me to sing the praises of the dome. I had just come back from a trip to Europe and I started my slideshow with pictures of a thatched-roof cottage in a field in Ireland. I said, Do you see what they did here? They took the rocks from this field and made fences and walls for the house. The materials came right from the site. Then they planted barley, and after they harvested the barley, they took the stalks and they made thatch for the roof. The reason this house looks so good is because it's made from materials that are from the site. And I said, Domes are the opposite of this. You're using the same geometry, the same design, no matter where you are. You're not paying any attention to local materials. You're not paying any attention to which way the sun rises or the wind blows. One standard shape for everywhere. (People were really angry with me. That's why I ended up putting together my book *Shelter*, as a kind of rebuttal.)

Since then I've experimented with and seen just about every type of alternative building technique you can imagine. The irony is that if I had to build myself a house today, it would be a regular old rectangular stud-frame house. The idea of radically reinventing the type of space people live in, constructing homes like acid trips—spaces inspired by fractals or nautilus shells or sweeping curves—that's not what I want to do. It just doesn't appeal to me anymore. I want to get a house built and I want to live in it and get on with my life.

That's my take on building—get a place to live in quickly and practically. To feel good, to choose materials that feel good. And I actually did that with domes. I tried to make domes feel good to be inside and not be like some scientific machine. I put rugs in them and things like that. I actually think the dome I built here on my property in California was the most beautiful dome ever built. It was salvaged wood on the inside, and the panels were silver. It had shakes on the outside. But I was trying to force a dome to do what a more traditional, hand-built home does naturally.

When people ask my advice about building a home, one thing I tell them is to really get a feel for the site. If you're going to build on a piece of land, go out and buy it and live on it for a year in a trailer or a little building. Pay attention to how the sun moves across the sky and which way the wind comes from. After a while you'll be a lot better qualified to design a house that fits the site than many architects.

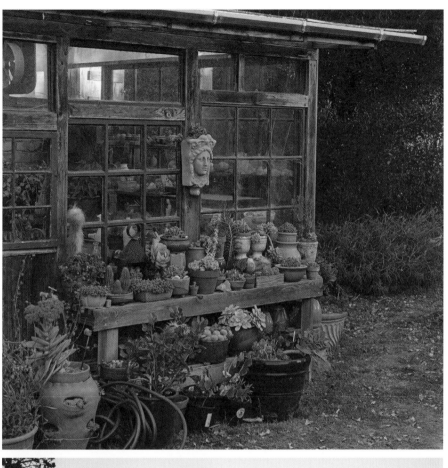

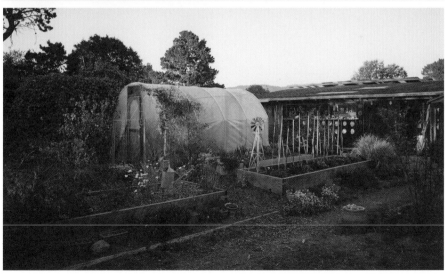

When it comes to building, I would start with a central core, something modestly sized that has everything your house needs. I would put in a woodstove with a coil for hot water. Up on the roof I would have solar panels. I would have a kitchen and a bathroom right in that center area with the woodstove, back to back, so all the plumbing and water heating is in one place. Then you can build a couple of rooms off the central area—enough space to live in. The beauty of stud building is that you can add on more space later if you want it. Say your family grows, or you decide you need a studio—just add it on. A home like that can grow organically over time.

add room *add kitchen*

In the sixties, the ideal was you found ten acres in the country and built your solar-powered house out there. Of course, it's a lot harder to do that nowadays. You couldn't do it at all in coastal California where I live, with the way codes have changed. When I built my home here in the seventies, my building permit was two hundred dollars and I was able to be my own architect, my own engineer, and draw all the plans myself. Nowadays, just getting a project like that off the ground can cost fifty thousand dollars.

I don't really have a problem with the uniform building code, because it's just trying to make buildings safe. It's good that we have inspectors and that

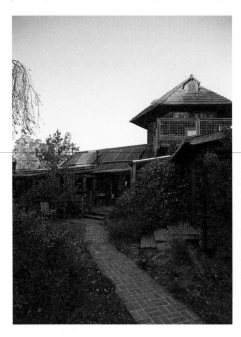

they make sure that people are building safe spaces to live in. But it's become absurd, say, around Marin County. There's just too much bureaucracy. All the permitting and inspection costs too much money. But farther away from urban areas you can still build the way I'm talking about. I think you have to be an hour or two away from any really big, desirable city. But farther get out there—and we're talking about most of the land in the country here—then maybe you can build your own home with your own hands and afford it.

There are other strategies, too. You don't have to go live in the middle of nowhere. You can find a little house in a town or a city that's run-down and buy it and fix it up. You want to make sure the foundation is solid, but everything else you can do for pretty cheap if you're willing to get your hands dirty. I know two couples who couldn't afford houses on their own, so they bought a big old house together and turned it into a duplex. And it worked. It was completely legal and it cost them half of what it would have to buy houses on their own.

The point for me isn't necessarily for everybody to live out in the country in some off grid house they built from the ground up. The point is to empower people to be involved in some way in creating or maintaining the space they live in. Making your own shelter with your own hands—that's what it's all about, whether you're building from scratch, buying a home with friends and subdividing it, or just fixing up a place.

Even living in a big city, there's always something you can do. Maybe you get into an old industrial space and set it up to live in. Maybe you don't have that kind of money. Maybe you're living in an apartment in the middle of Manhattan and all of this is just a distant idea that feels unattainable. You can still build a planter and grow parsley on your fire escape.

In reality, self-sufficiency is not attainable. It's like perfection. It's a direction. You can't approach this type of lifestyle thinking, "Okay, I'm going to be one hundred percent self-sufficient." It's not going to happen. You want to go toward self-sufficiency, you want to go toward perfection, and not get hung up because you can't do everything.

People get so wrapped up in planning, in making everything perfect and doing it all right, that they never actually get moving. I want people to just start—somewhere, anywhere. There are things you can do today with your own hands to be more independent, more self-reliant and self-sufficient. And once you start moving, then you get to see how far you can really go.

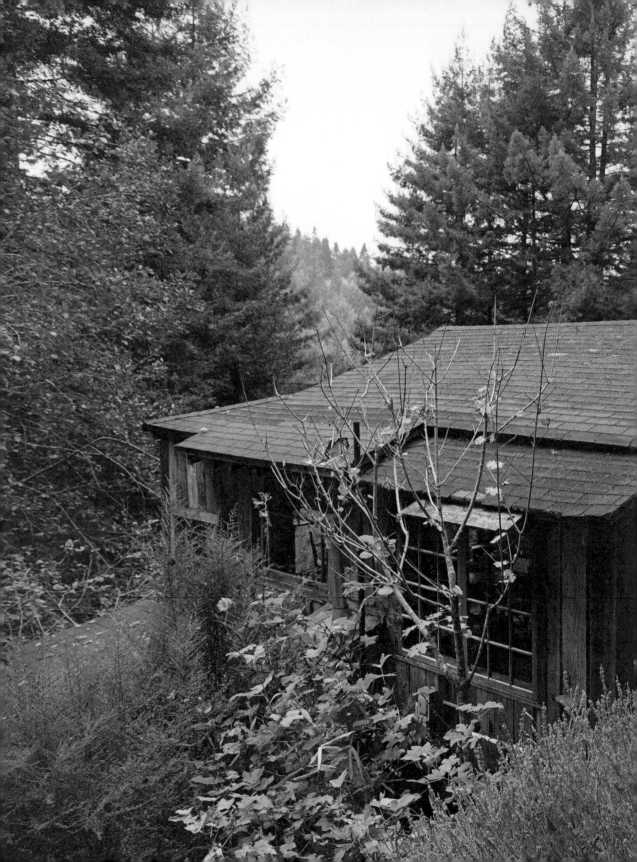

CHAPTER 1
CABINS

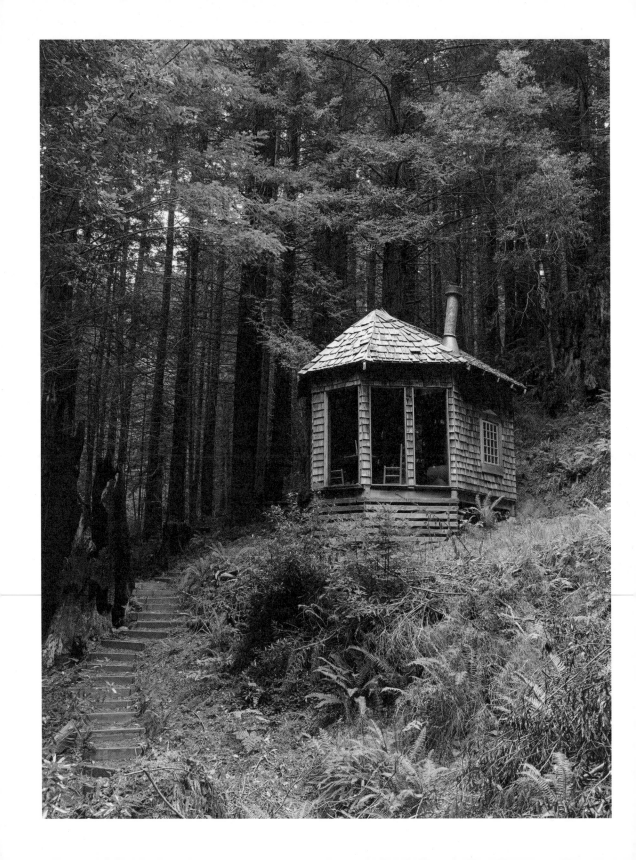

Rebirth of an Old Commune with Artist Fritz Haeg

Fritz Haeg is an artist and builder living in Mendocino County, California.

My life as an artist has happened in chapters. For many years I lived in L.A. and was very engaged in community projects and the local art scene. Around 2005 I felt a conscious urge to start traveling. For the next ten years I was going to different cities all over the world, working on commission pieces. But from the very beginning, I knew that one day I wanted to live rurally and have a more settled life.

In 2006 I collaborated with a friend on a project called Plan B. We did a massive amount of research on intentional communities around the world and put together five binders of documentation, one for each continent. We used the material to create an installation at MASS MoCA exploring failed utopian projects. So even at that early moment, communal living was a real interest for me and something I had spent a lot of time thinking about. There just wasn't any place in my life for it yet. It's one of those ideas you let germinate while other things are happening.

During that whole period of time, I was nursing this dream. I had a very specific idea of wanting to be settled, rural, connected to a piece of land for the rest of my life—a place where I could literally and meta-phorically put down roots, plant trees and things I could grow with for

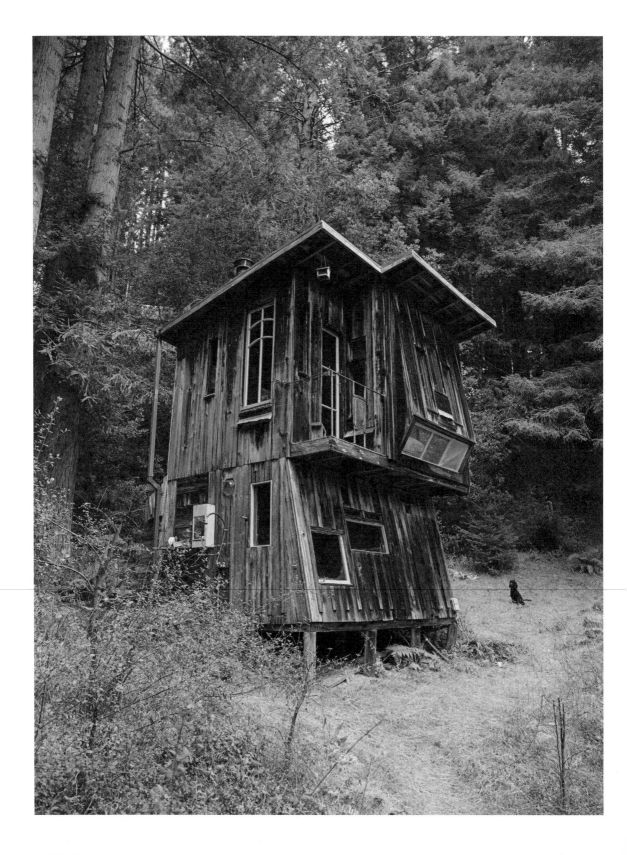

the rest of my life. I knew I needed the perfect piece of land, because it had to be something that could be the next project for the rest of my life, something that I could put all my resources and time into. I didn't want a virgin piece of land. I wanted something that had a legacy to build upon, maybe a homestead or an old farm. What I found was even better.

The Salmon Creek Farm was founded in 1971 by Robert Greenway, a professor at Sonoma State, and his partner, River. They had a blended family of seven kids, including six boys. Salmon, Huckleberry, Hawk, Rainbow—they all had these amazing commune names. Originally, Greenway's plan was to start a school, but later he developed this idea of an intentional community, very similar to communes going on all over California at the time. They had a very organized system for joining the group. Everyone was a partial owner of the property and everyone

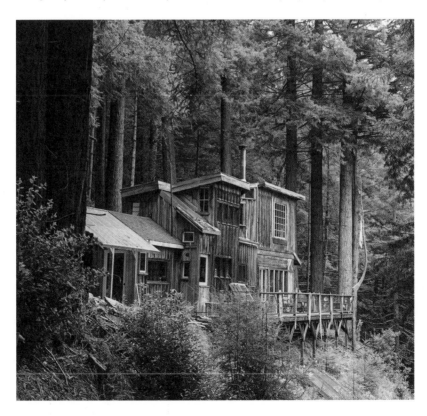

had a vote in community affairs. The group divided labor and chores systematically. They had a charter and a clearly articulated vision for the society they were building. They were also very much a part of the counterculture. They had peyote circles and solstice rituals. They grew their own food. They built their own cabins from materials scavenged locally.

Over time, people left and the community faded away. When I bought the property in 2015, there were thirteen owners spread all over the globe. It made communication a little difficult, but when I explained my vision for the future of the land, they agreed to sell me the property for less than market value.

My vision for the Salmon Creek Farm is eclectic—a hybrid of different aspects of art, education, and community that I believe in. I was never interested in reviving the commune as it was before, but the community was built with certain principles that I think are truly universal and timeless: resourcefulness, simplicity, self-reliance, respect for the land.

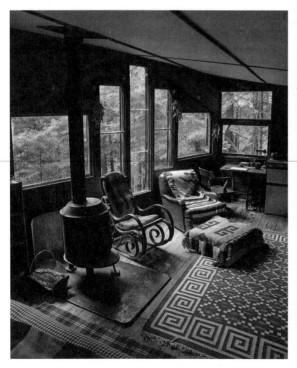

I think one thing that keeps a lot of people from going back to the land is this idea that you have to be perfect at everything—building, farming, all that. But that's not really true. I think one of the things that is really inspiring about Salmon Creek Farm is that everything was built by kids in their twenties using scavenged materials. They didn't know what they were doing. They were making it up as they went along: reading books, getting pointers from locals, that kind of thing. It is empowering to spend time in the cabins they built because you think, "I can do this too."

There are sacrifices you have to make to live this way, but you are rewarded with a much deeper feeling of connection to the processes that support your life. I want people to come here and have an experience where they feel cold and damp in the winter. That is such an important feeling to me. It is part of the landscape. You can't just go into a building here and push a button and be warm. You have to have an encounter with the trees to warm yourself—harvest the wood, buck it, chop it, season it, burn it. You are connected with the whole cycle.

I get young people writing to me and coming to visit from all over the world, and obviously there is a groundswell of desire from the younger generation to reconnect with the land and get out of oppressive structural systems like economy, education, and debt. I don't know where it is all headed, if a movement like the one that happened in the early seventies is possible again, or if it is even desired. But I do know that we should be learning throughout our whole lives. We should find ways to be constantly growing and changing and learning new skills, crafts, and trades. This idea that you go to school an empty vessel, all this information gets poured in, and then you live your whole life in that tank is crazy to me. The way I live my life as an artist is by constantly moving laterally to new things. I started with architecture, and then at a certain point gardening became my obsession, and that's what all my work focused on for years. I love that feeling of being amateur at something new. I love that feeling of being nineteen again and picking up some new trade. I think that is something many people crave. Modern life is so cerebral, and coming back to a place like Salmon Creek Farm is a way of reconnecting with our lives and our true potential.

CABINS
ARCHIVE

Roman Schnobrich | *The Encampment* | Billings, Montana

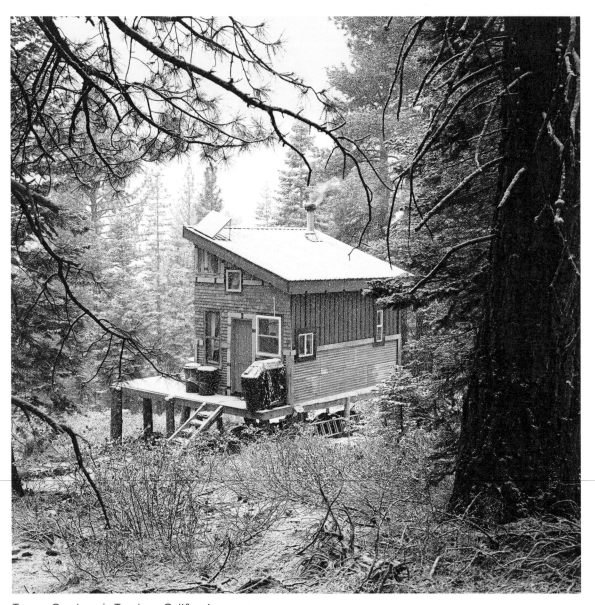

Trevor Gordon | Truckee, California

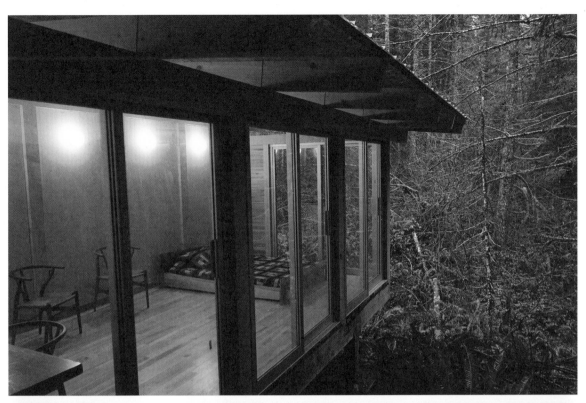

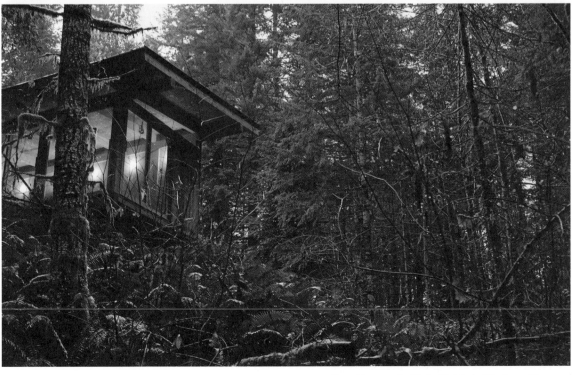

Ben Hayes | *Hyla Huts* | Timber, Oregon

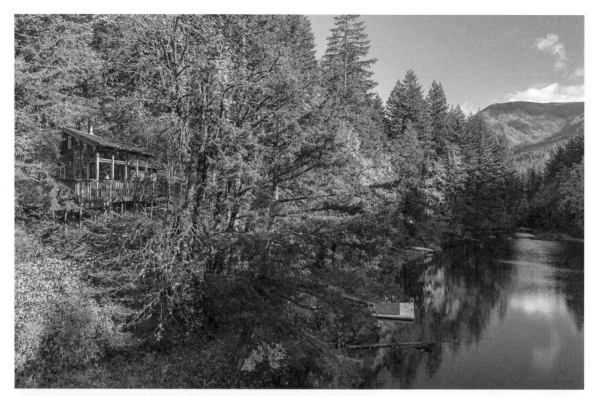

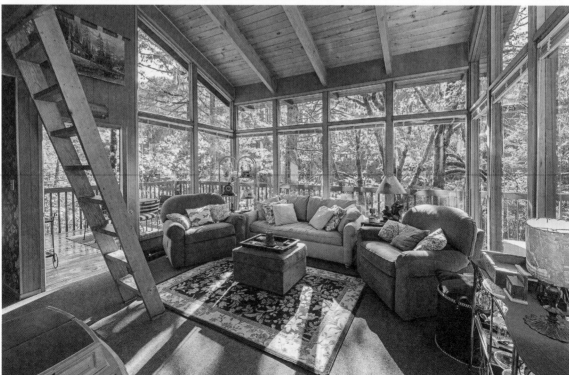

Dan Huntington | Columbia River Gorge , Washington

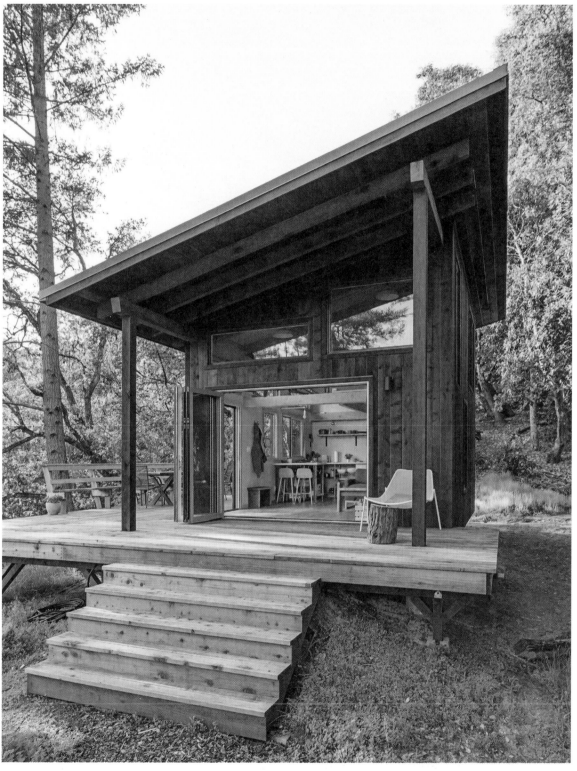

Jeff Waldman | California coast

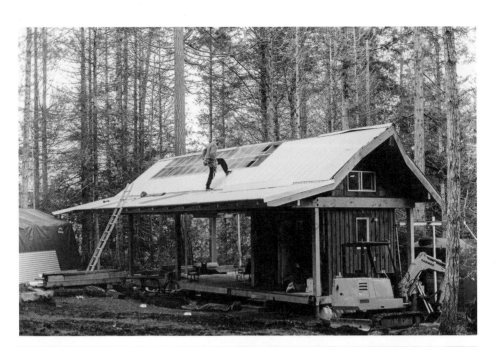

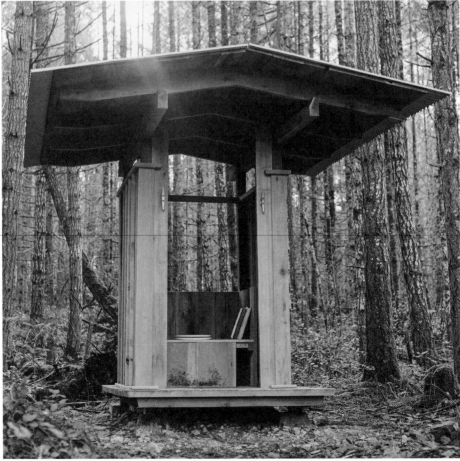

Alana Paterson | *Lost Chainsaw* | Gabriola Island, British Columbia, Canada

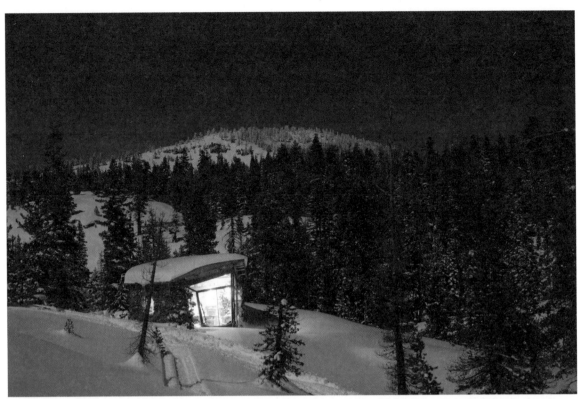

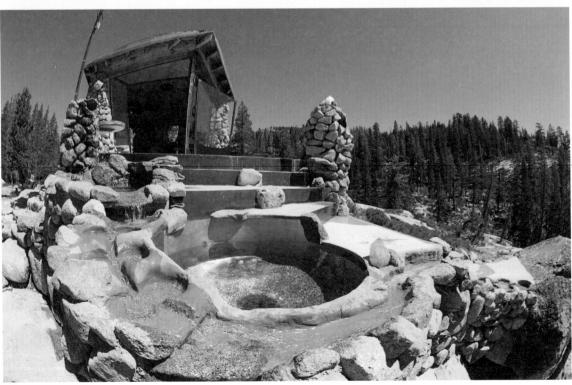

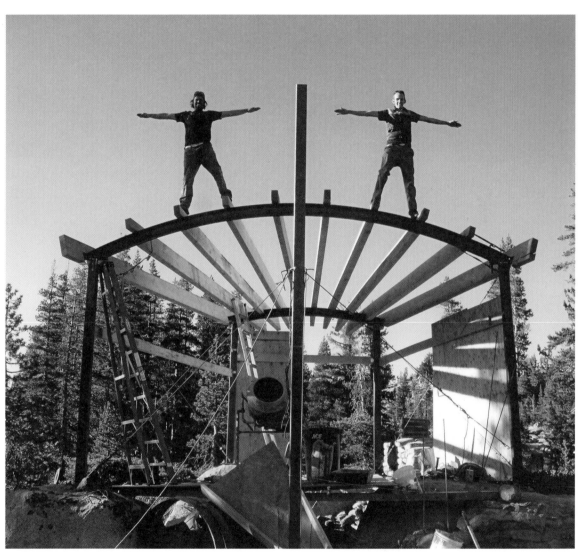

Michael Basich | Donner Summit, California

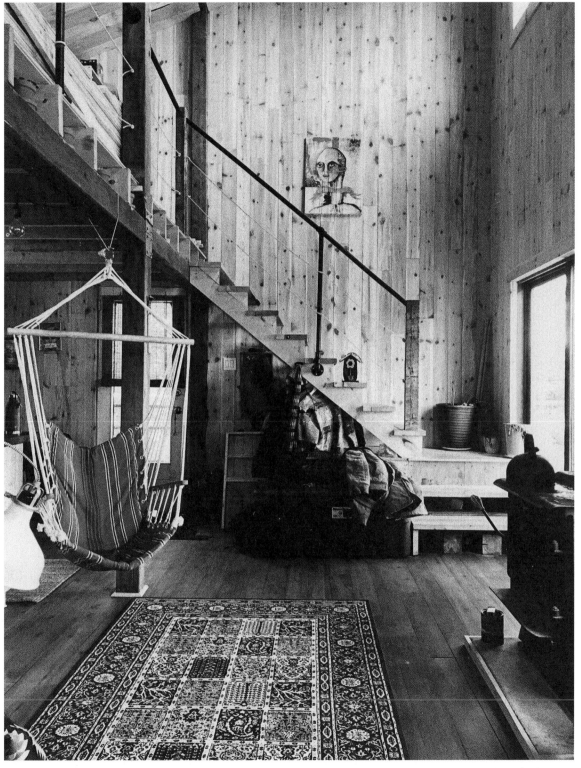

Sacha Roy | Canada

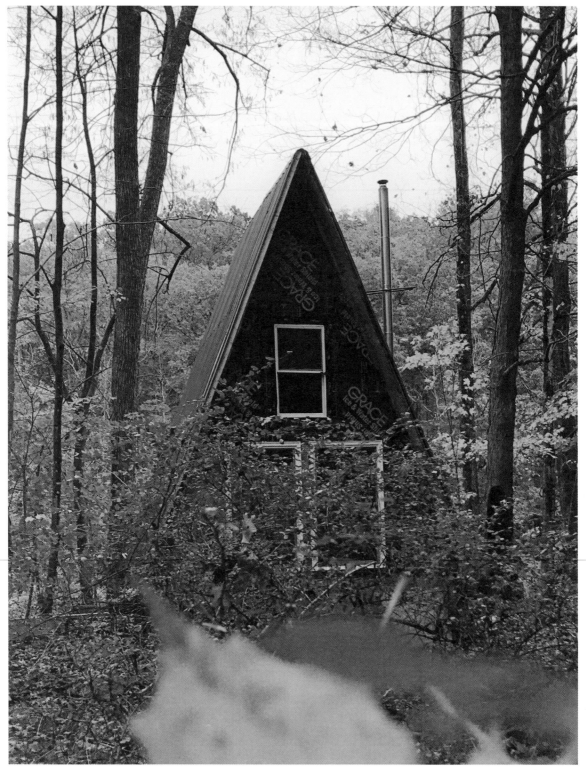

Vince Dickson | Hudson, New York

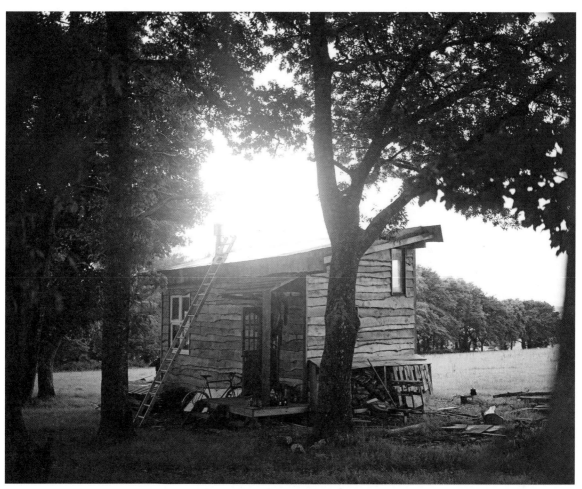

Samuel Glazebrook | *The Cabin* | Elbow Lake, Montana

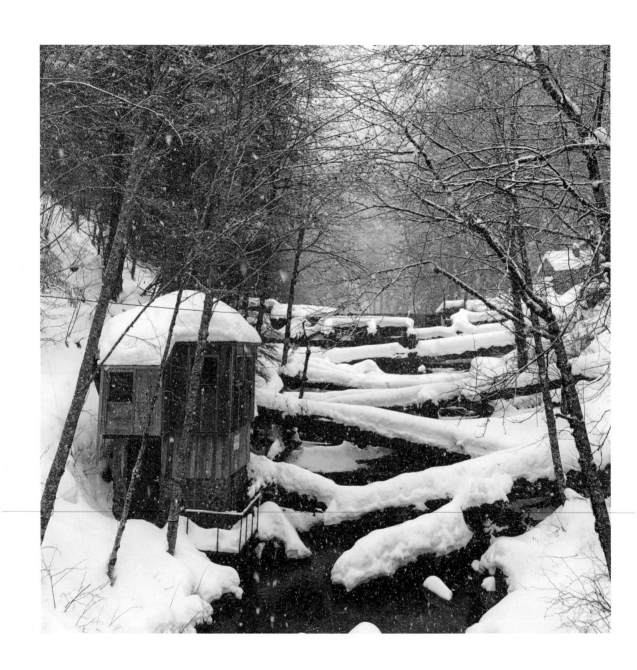

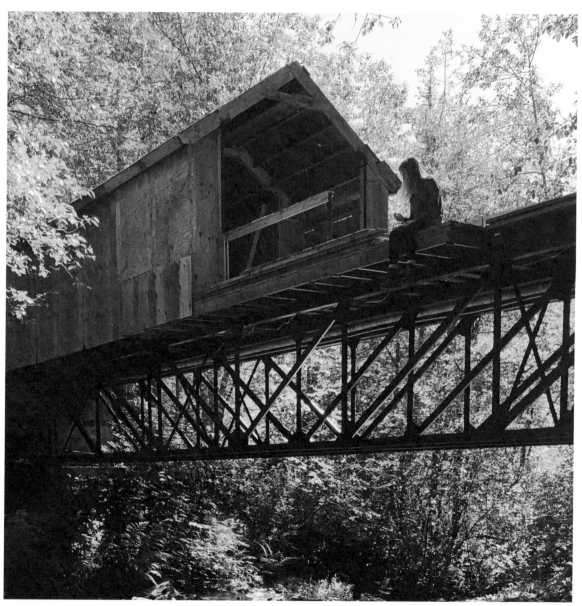

William Winters | *I'm Going to the Dam* | Washougal, Washington

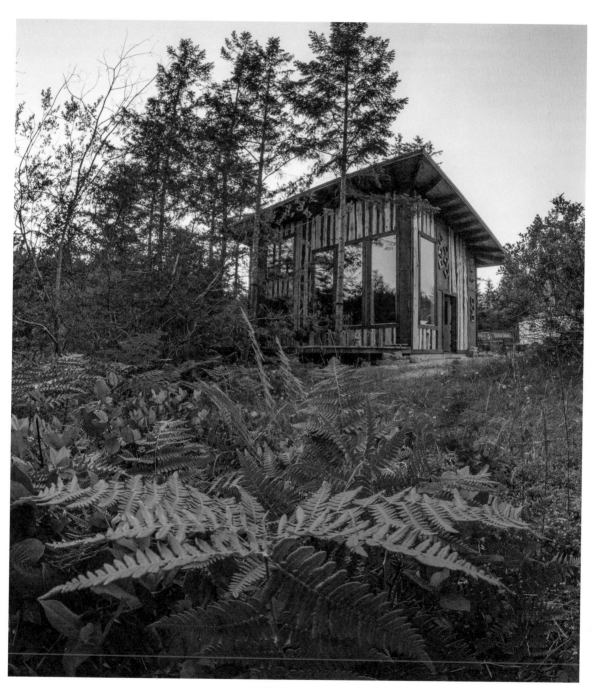

Michael Murphy | *The Temple* | Grapeview, Washington

Winows
close together
metal roof

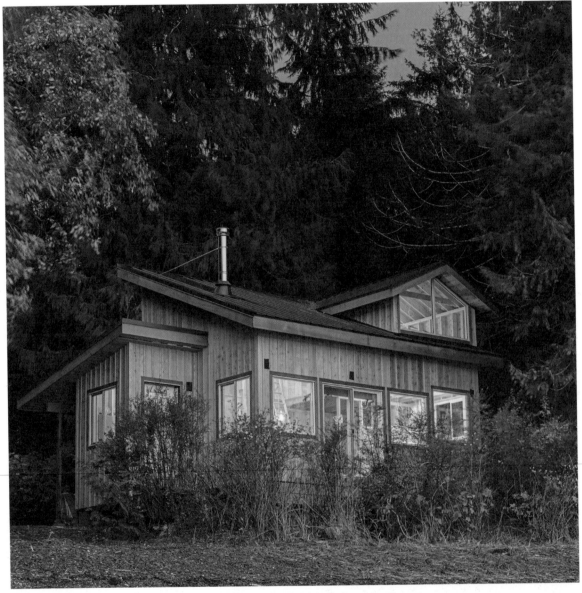

Shea Pollard | *Betty's Tiny Home* | Haida Gwaii, British Columbia, Canada

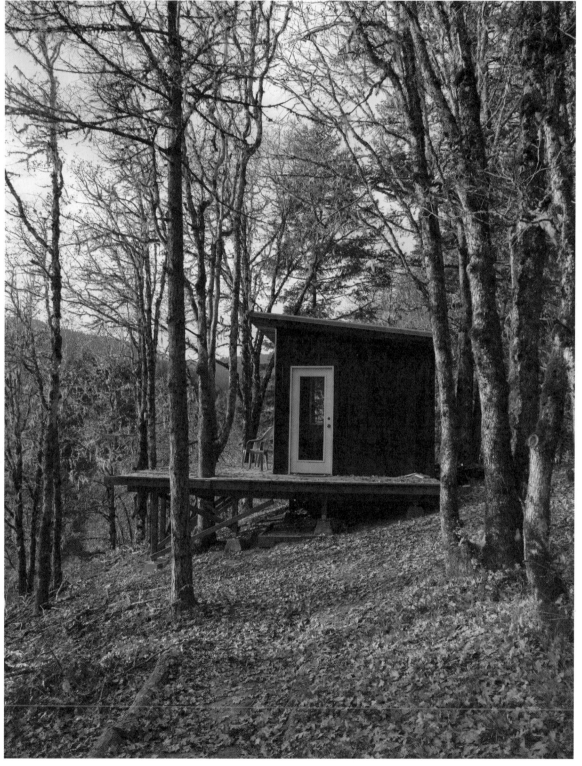

Scott Cushman | Underwood, Washington

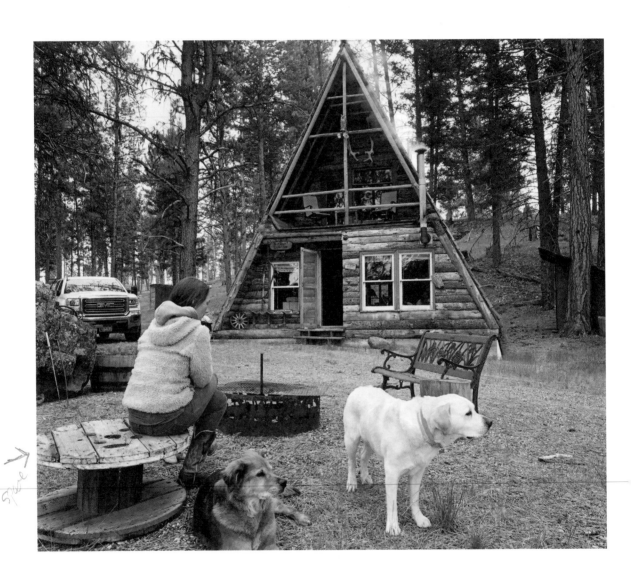

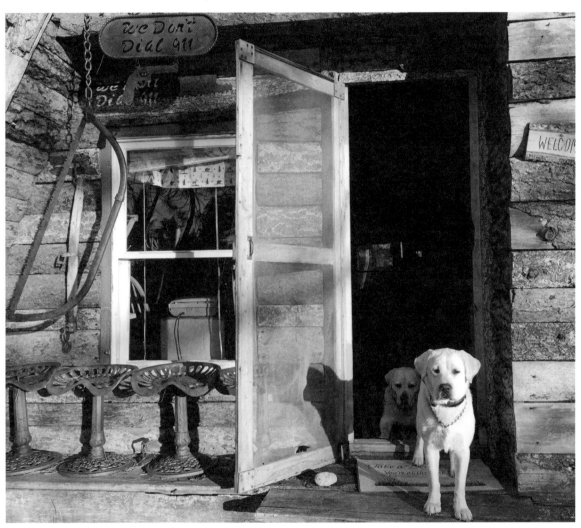

Amy O'Hoyt | *The Cabin* | Elbow Lake, Montana

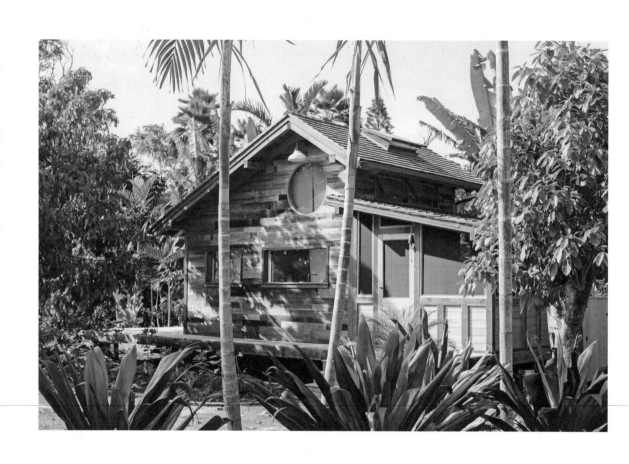

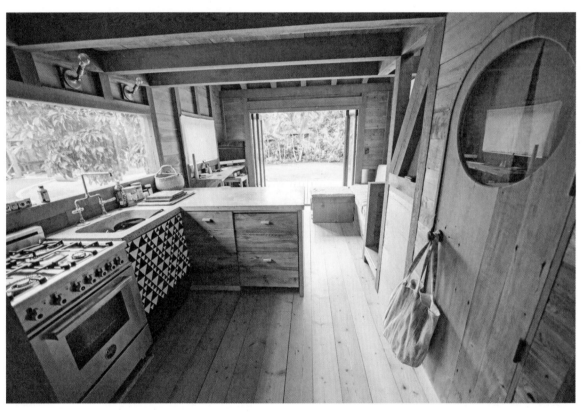

Jay Nelson | Hawaii

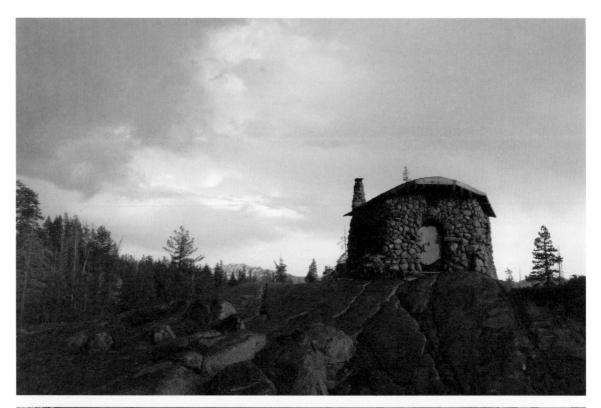

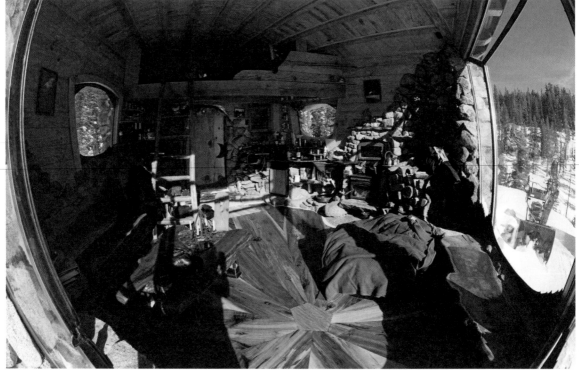

Michael Basich | Donner Summit, California

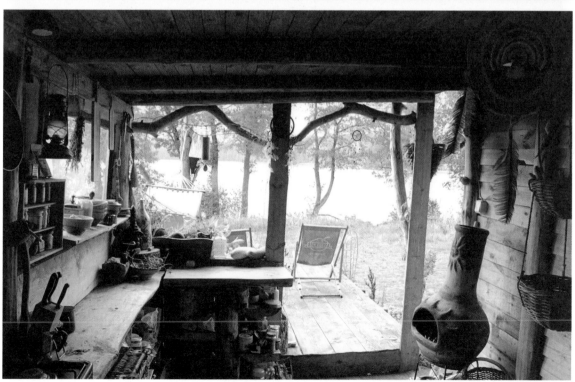

Adam Ram | Silent Lake, Poland

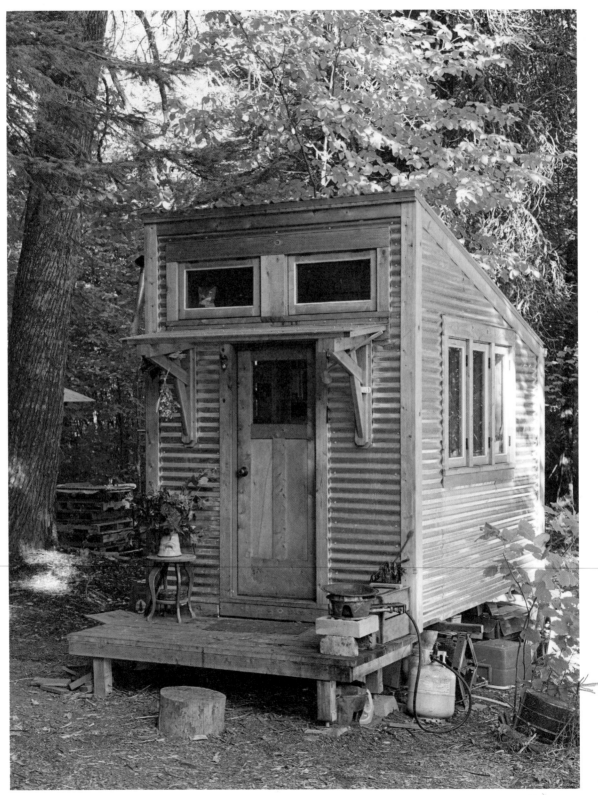

propane tank
thge

Off Grid in the Pacific Northwest with Tree Climber Ryan Cafferky

Ryan Cafferky is a tree climber and arborist living in Hood River County, Oregon.

ESSAY PHOTOS BY FOSTER HUNTINGTON

I came up to Hood River County in 2009. When I first moved into the cabin, it was pretty rough. One 12x24-foot room, very spartan, with a porch off the east side. First thing that I did was completely redo the kitchen, which was in really bad shape. Then I ripped off all the siding on the whole place because it was uninsulated, other than being full of mouse nests and carpenter ant nests. And then a couple of years ago, I added on two 8x12 additions, one on the east and one on the west side.

In terms of heating, all that was here was a propane burner and a woodstove. There was no hot water system, no solar. For light I used headlamps, kerosene lanterns, or candles. It was like that for years. I didn't put in solar until 2015. I bought a system from a friend who moved away, just a couple of panels hooked up to a charge controller and an inverter with four 6-volt batteries. Those original batteries were deep-cycle, what they call golf cart batteries. The next batteries I went with are called AGM (absorbent glass mat) batteries. I bought those from a guy in Portland who had salvaged them from an old cell tower.

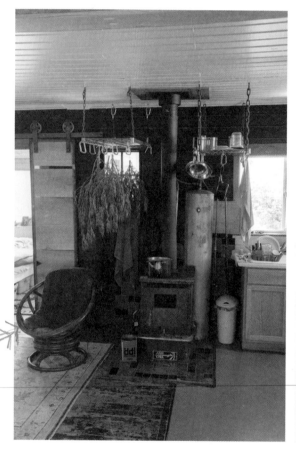

The solar system I have now is much larger. There are four 240-watt panels out in the garden area, and all that power runs into the charge controller in my house and gets stored in a 24-volt, 100-amp hour lithium ion battery. They are amazing pieces of technology.

One of the keys to living off the grid is learning when to use power. It's not a good idea to do a load of laundry and vacuum at nine-thirty at night. That's a nine-thirty in the morning kind of thing. You have to be careful about when you use power, and constantly ask yourself, "How much power do I have? Is this a good time to do this?" That's one thing I found very difficult when I first moved out here.

We get water from a natural spring about 2 miles from the cabin. Maintaining all the pipes is a lot of work. Any time there is a break or a leak, I have to fix it. I am the water company.

For hot water I have a completely passive system made by a company called Hilkoil. They custom-make coils to fit woodstoves. Basically, you have a metal pipe coming out of a water tank that coils around the inside of your woodstove and goes back into the same tank. When you have a fire going, the heat draws the cold water out of the bottom of the tank and warms it up, and the hot water then flows back into the tank. It's a super simple system. It doesn't require any pumping or electricity. It's probably my favorite thing in my house. In the winter when I consistently have a fire going, the thermal mass of the water will keep my cabin warm for up to twenty-four hours after the fire goes out.

For perishable food I have a standard chest freezer with a special aftermarket temperature control unit. You just plug it into the wall and it has a thermometer that hangs inside the freezer and measures the temperature. You can set the unit to come on at any temperature and turn off at any temperature. I have mine set to turn on when it reaches 39 degrees Fahrenheit inside the freezer, and then I have the temperature differential set for 5 degrees. That means that the freezer will run until the temperature inside gets to 34 degrees and then it will turn off. That way, the food doesn't freeze.

I've always liked having separate structures. Originally, I had the little cabin and then I built a treehouse as my bedroom, figuring that I could just use the cabin as living space. Now that I have the additions,

I've moved my bedroom back into the cabin and I use the treehouse as my guesthouse. I got a shipping container this year, which has made a huge difference, because I've been able to declutter the house. I like the house to be more empty and have all the tools out in the shipping container. It's all evolving over time as I build more and add more space.

People ask me how I learned to do all the little things you have to do to live off grid. You need to be very handy and self-reliant. And I tell them, you know, I didn't start out this way. I've just been doing it for a while. Occasionally I'll do a little bit of reading, but most of the time it just comes down to experimentation. I'll just be browsing Craigslist and I'll look at something, some object, and I'll think to myself, "Huh, I wonder if I can make that work"—for example, for refrigeration. It's all about thinking creatively and being willing to experiment.

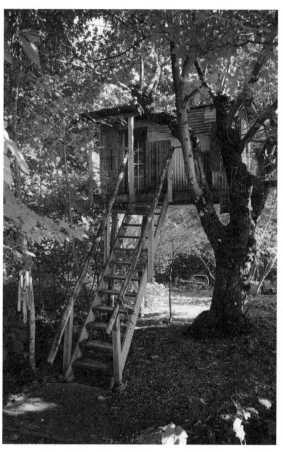
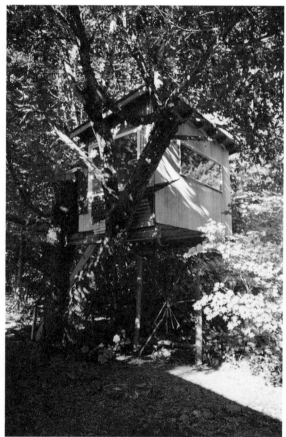

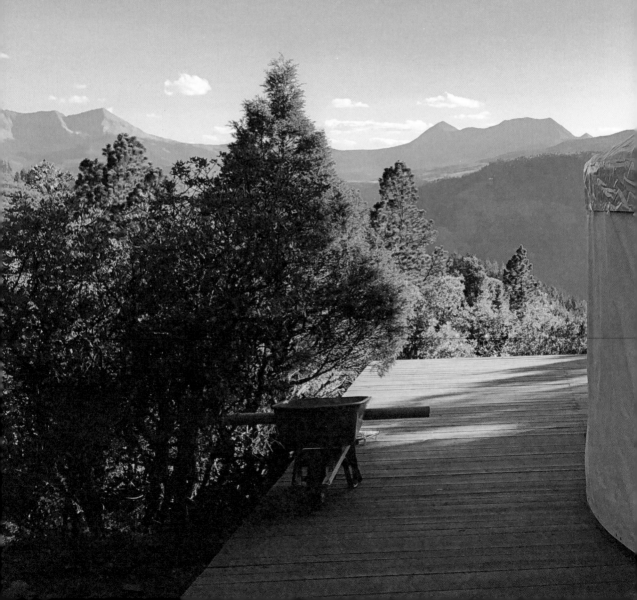

YURTS, TENTS, AND HUTS

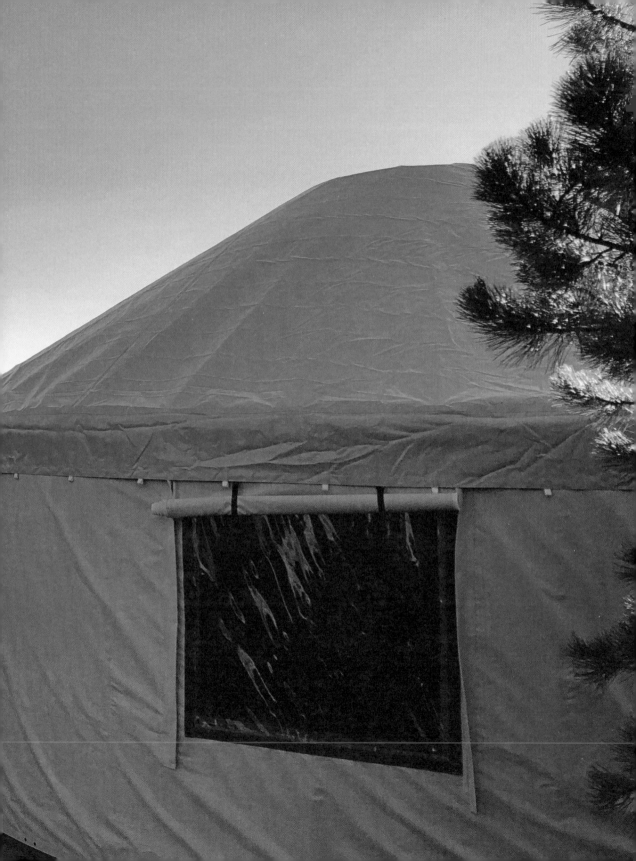

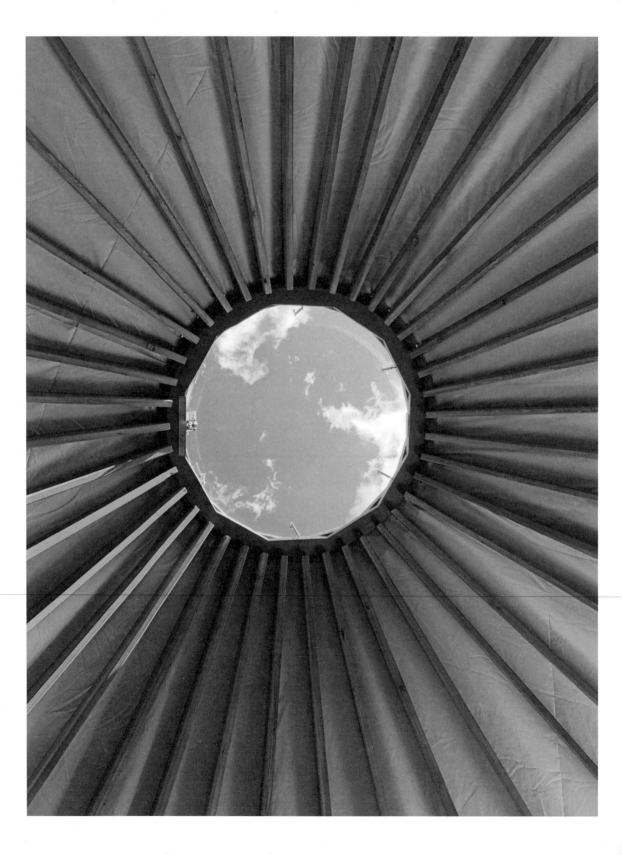

Living Off Grid at Nine Thousand Feet in a Yurt in the Rocky Mountains with Steven and Hanna Nereo

Steven and Hanna Nereo live in San Miguel County, Colorado. They both work as photographers.

We moved to Colorado from Los Angeles three and a half years ago. Our property is at 9,100 feet and we originally bought it intending to build a cabin or a house. For the first summer we lived here in our van and got a feel for the site. We realized that building a house means dealing with architects, builders, plans, permits. With the yurt we didn't need any of that. It was something we could do immediately.

As we started to research yurts in more detail, we discovered there are basically two main companies that manufacture them: Pacific Yurts, which is based in the Northwest, and Colorado Yurt Company, which, it turned out, was less than an hour away from our property. That seemed like a sign to us. There are also a lot of people living in yurts in our area, so we knew that they work well in the Colorado climate, and felt like

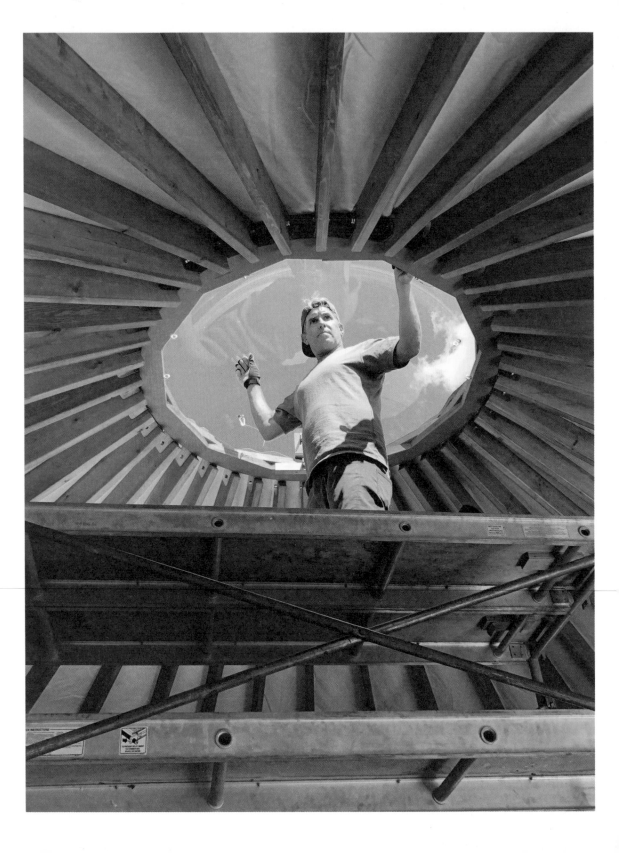

we had access to a knowledge base and some good resources. Another nice thing about yurts is that you know exactly what you're building. It's a very specific design with well-established steps and materials. A cabin can be built out of anything, and it can take any shape. That would have been overwhelming for us, fresh from the city and working on our first construction project.

Once we'd selected the site, we had a deck built professionally and assembled the yurt ourselves. After we put down the flooring, we had two days to get the structure up so it wouldn't get ruined by rain. All we had was a manual, some tools, and the materials. We had no idea what we were doing. There were some times it felt really hard—even impossible—and some times that were just plain funny because we were so clearly in over our heads. But in the end, we did it. It was hard to believe at first, and there was a tremendous feeling of satisfaction.

Our yurt is completely off the grid. We have a composting toilet and a 110-volt solar system. We heat with wood, but it's amazing how

110V
Solar
System

warm yurts are, even in the winter. Most of our windows face south and we get a lot of sun exposure.

When you're part of the building process of the home you live in, you feel closer to the project and closer to the creation. It connects you with why you're getting away from the city in the first place. You feel the functional aspects of the lifestyle, learn that you can actually build and fix things and find joy in that process. It also helps you become less wasteful. So many of us are overly quick to replace things that could be mended, or to pay others to fix problems we're perfectly capable of taking care of ourselves.

When you move from an urban area to a rural area, there's a natural impulse to try to replicate all the conveniences that you had in a city, and the reality is that you just don't need a lot of it. Go slow and figure out what you really need.

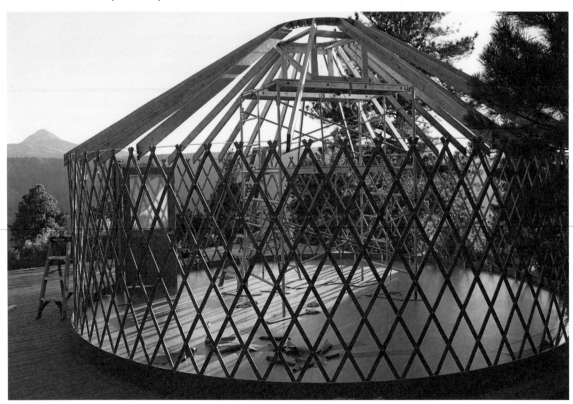

When it comes to filling up the inside of a yurt, you definitely don't want to just go out and get a bunch of Ikea furniture and stick it in there. A lot of yurt builders feel the need to compartmentalize the interior and make it into a bunch of distinct interior spaces like in a suburban home. But you feel the architecture much better when you leave it open. That sense of openness and space diminishes considerably when you approach the layout more traditionally, saying, "Here is the dining area, here is the kitchen area, here is the sleeping area." So from a spiritual perspective, it's best not to mess with the open architecture. It's been around for a long, long time. Our interior is 435 square feet, and the openness of it feels so expansive and roomy that we don't even use the whole space.

Three years ago when we left L.A., people were dismissive. Now that's starting to change. Friends are calling us up, asking, "So where did you go again? How is it working out?" There's also a greater feeling of freedom today.

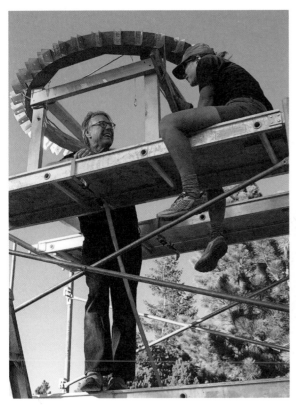
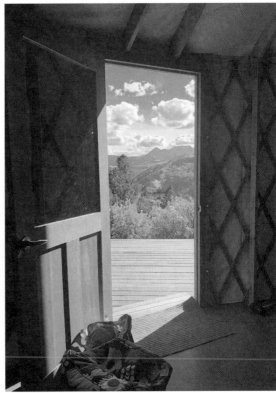

The internet connects us no matter where we are. We function pretty normally, even out here away from urban society. Hopefully technology will empower more and more people to make the kind of change we did.

It was a really crazy transition at first. We have to worry about a lot of things we never had to worry about in our lives, like our dog getting gored by an elk. But we don't have to worry about traffic, or utility bills, or the daily grind. It's not easy, but there's something more carnal, more wholesome about a life like this. Being able to function outside of an urban center, face new challenges, and pick up new skills is really special.

When we first came out here from the city, our dog was the quickest to adjust. He just transformed overnight. It was like in *The Call of the Wild*. He's a wolf now, running wild, howling at the moon. We're moving in that direction, too.

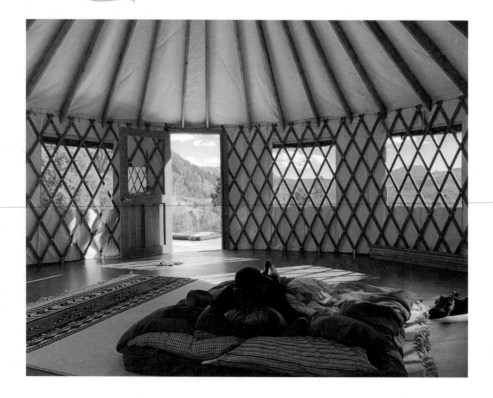

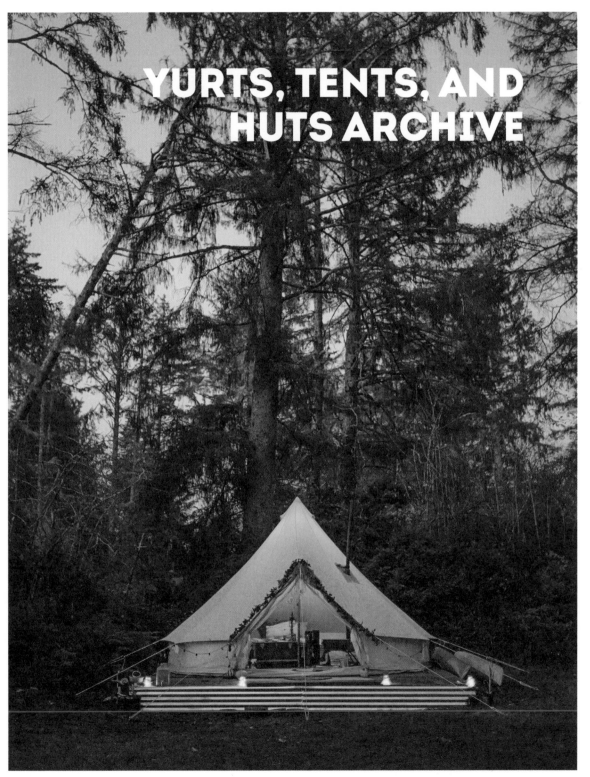

YURTS, TENTS, AND HUTS ARCHIVE

Sora Blu | *Loomis Bell* | Loomis Lake, Washington

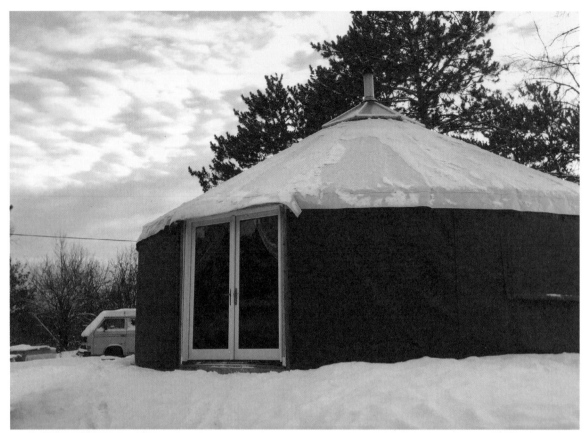

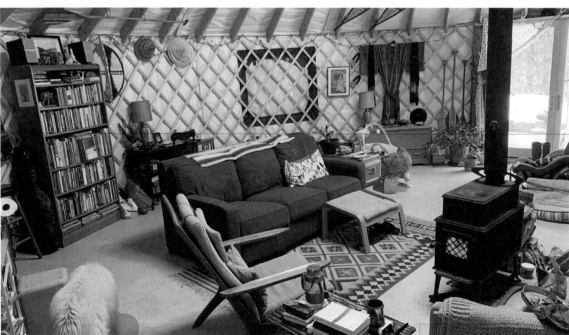

Alexia Springer | Eagle Eye | Ely, Minnesota

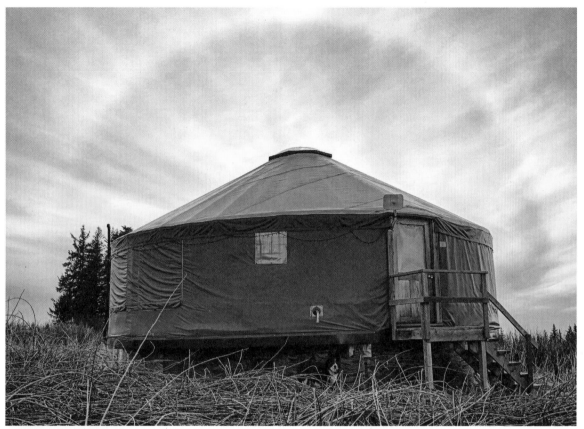

Michael Becker | *The Diamond Ridge Yurt* | Homer, Alaska

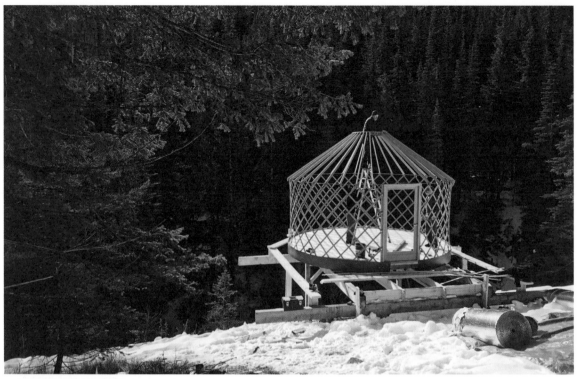

Ethan Suitter | *Bullfrog Basin Yurts* | Idaho Panhandle National Forest

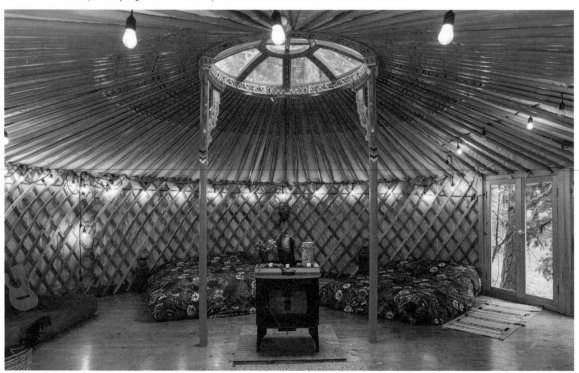

Belinda Liu | Northern California

Ansel Ogle | Dean, Arkansas

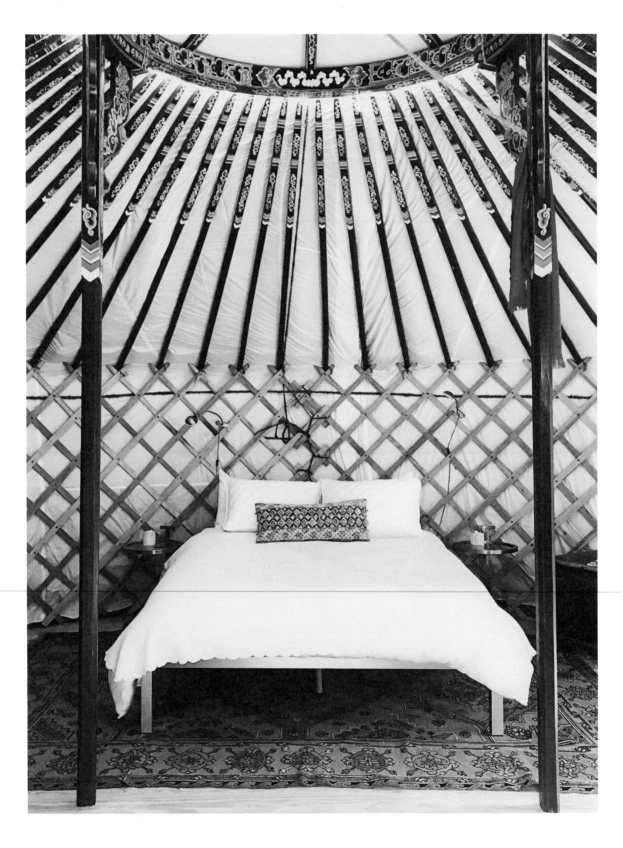

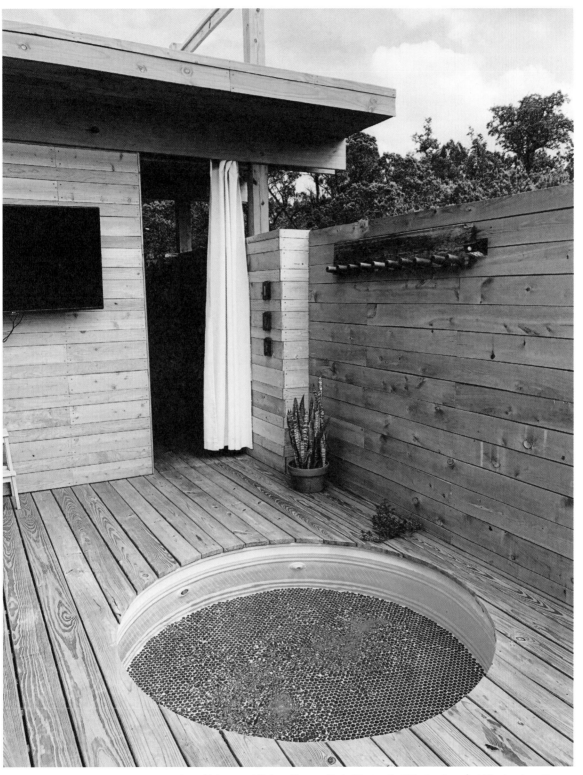

Ann-Tyler and Brian Konradi | *Yurtopia Wimberley* | Wimberley, Texas

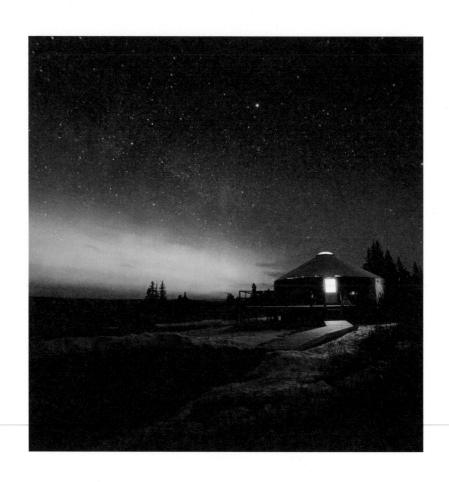

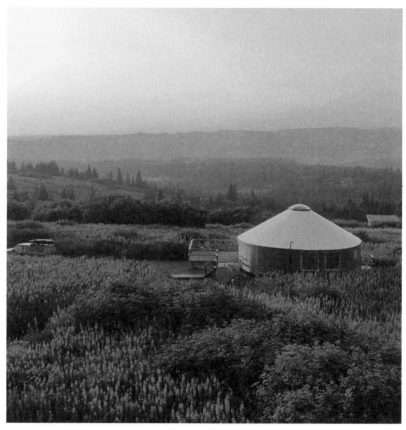

Michael Becker | *The Diamond Ridge Yurt* | Homer, Alaska

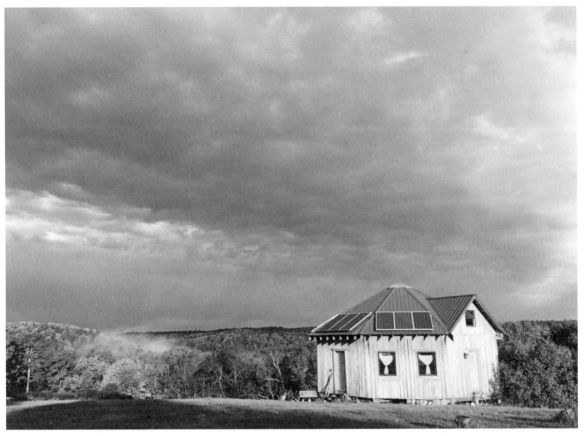

Ansel Ogle | Dean, Arkansas

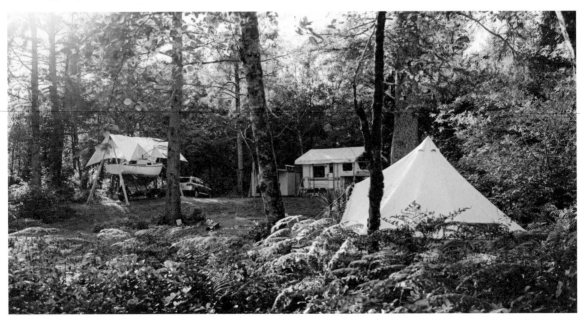

Sora Blu | *Mounika* | Ocean Park, Washington

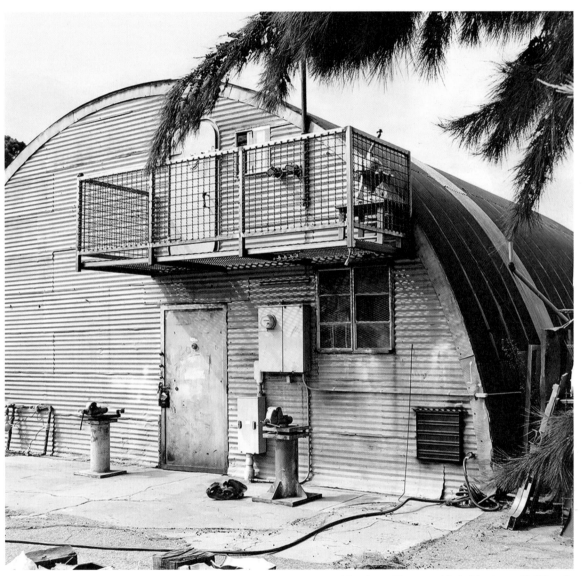

Matthew Furmanski | Ventura, California

CHAPTER 3

EARTHSHIPS AND UNDERGROUND STRUCTURES

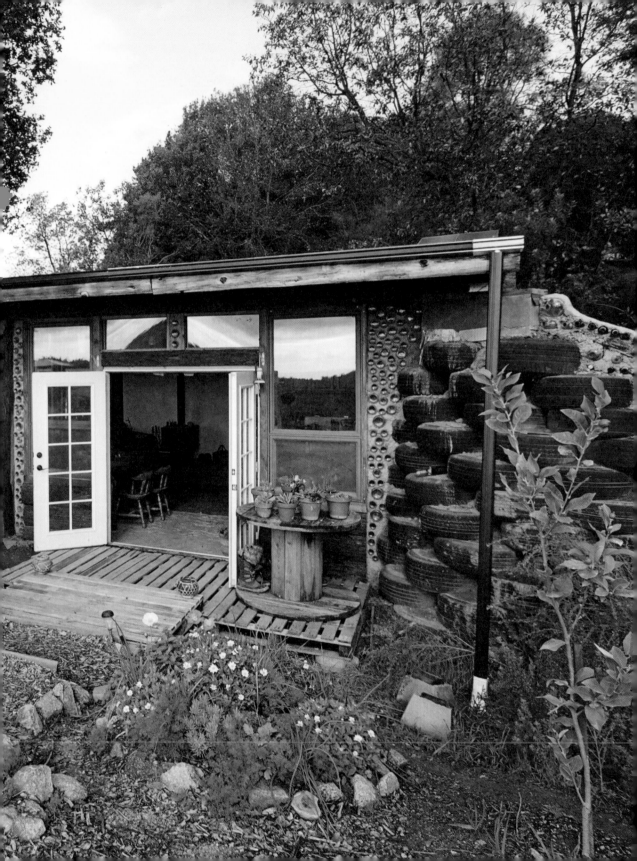

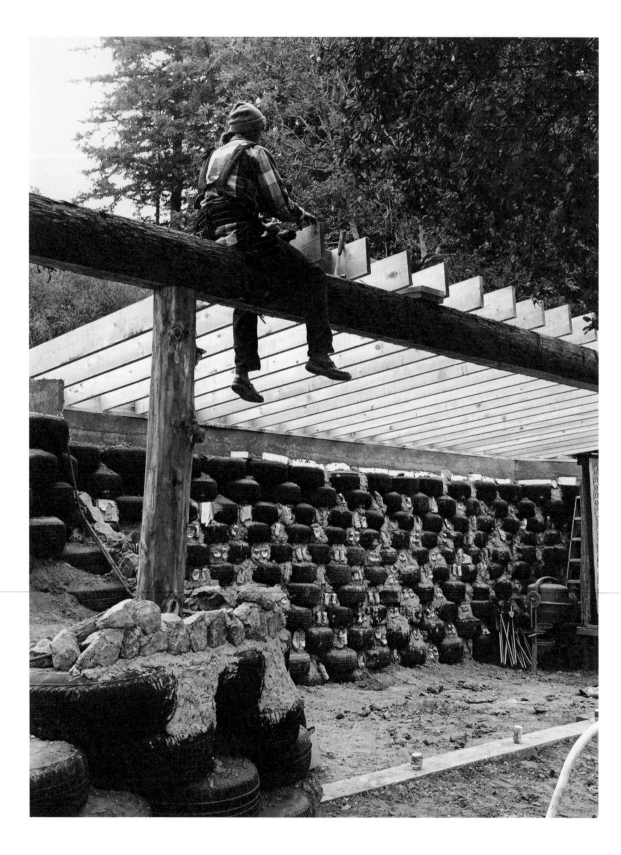

Building and Living in an Earthship in the Santa Cruz Mountains with Builder Taylor Bode

Taylor Bode is a builder and artist living in Santa Cruz County, California.

My wife, Steph, and I were living in Taiwan when we first discovered Earthships. We were in our early twenties, teaching English abroad so we could see the world on the cheap, and we came across a documentary called _Garbage Warrior_. It's about Mike Reynolds, the creator of the Earthship design, and the whole philosophy surrounding it. Up to that point, we knew nothing about alternative construction. The ideas behind the Earthship—passive solar heating, earth-bermed design, building with recycled materials—were incredibly inspiring to us.

We dove in deep. Within a year we had moved to Taos to attend the Earthship academy, and before long we were traveling around the country helping crews with construction. Pretty soon we felt like we had enough experience to build our own, so we decided to explore the West Coast and buy a piece of land to live on. We started in San Diego and drove north, searching for a place that felt right. We found it in Santa Cruz.

Looking back, we had no business trying to find real estate in Santa Cruz. We had no money. But in the end, we didn't need any. A friend

Garbage Warrior documentary

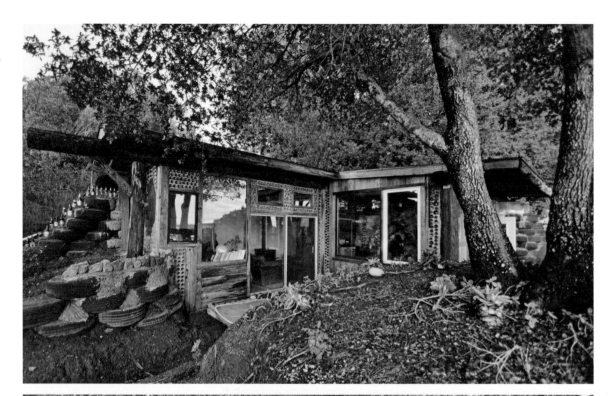

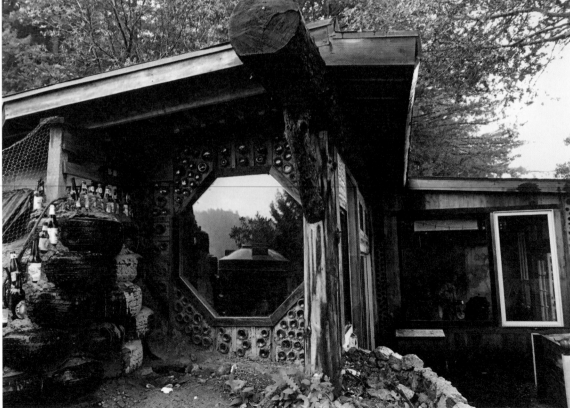

introduced us to someone with a big piece of land. Our plan was to camp there as we looked for jobs and saved up some money, but when we started talking to the landowner and explaining our dreams to him, he offered to let us build on his property for free.

From the very beginning, the whole theme of the project was to try to spend as little money as possible and see what the universe would provide for us. All sorts of things fell into place. We put an ad out on Craigslist for a woodstove and a guy delivered us one for free. Other people traded us labor or gave us materials.

Kids always want to be in a treehouse or a cave. There is some primal attraction to living in the earth and in the sky. And there is precedent in human history, too. Just look at Chaco Canyon in New Mexico or Montezuma Castle down in Arizona. These are places where you feel the safety and the strength of the earth, but you can also look out over the vast open plain and see your predators coming.

When you live underground, like in an Earthship, there is an unavoidable feeling that you are literally entering into the Earth in some way. You feel it. The temperature is different when you walk in. With the south-facing bank of windows, you see the sun every morning as you wake up. You see the direction and angle of the light as it changes every day throughout the year. As you sit and watch these small changes, you become more connected to the fact that the Earth is this giant sphere flying through space. You become aware of all these subtle things you never noticed in the chaos of the city. We found ourselves going to bed when it started to get dark. We would sleep more in the winter. We would wake up earlier when the sun rose early. We started adapting our lifestyle to the changing seasons and the sunlight coming through the mouth of our cave.

When people ask me for recommendations on building an Earthship, the first thing I tell them is to consider the climate where they want to live. There are a lot of areas out there where Earthships are perfect. Given the right conditions, they can provide so much autonomy over your life. But in the wrong climate a lot of their advantages become liabilities.

I knew a guy who wanted to build an Earthship down in Guatemala. We started talking about it and looking at the conditions down there,

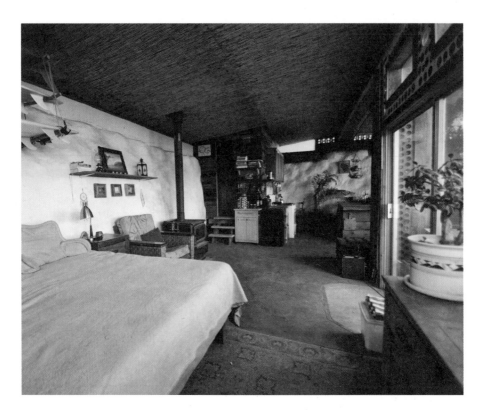

and within an hour, we realized that the site he had in mind was no place for an Earthship. We started talking about bamboo instead and it quickly made much more sense. I think it's important to remember that ultimately the best solution is the best solution. You should never start with a predetermined idea of a building and then try to make everything else conform to it. You have to respond to the site.

The second thing I tell people is that building an Earthship is a *lot* of work. It's an extremely labor-intensive way of building. It takes a village, and if you can find some friends to help sometimes, you're going to be much better off. Otherwise, strap in for many, many months of grueling work. But I don't say that as a deterrent. For me, the work was richly rewarding. And in the end, the extra labor is what made the whole thing possible. By building everything by hand from recycled materials, we were able to realize our dream of living in an Earthship for only ten thousand dollars.

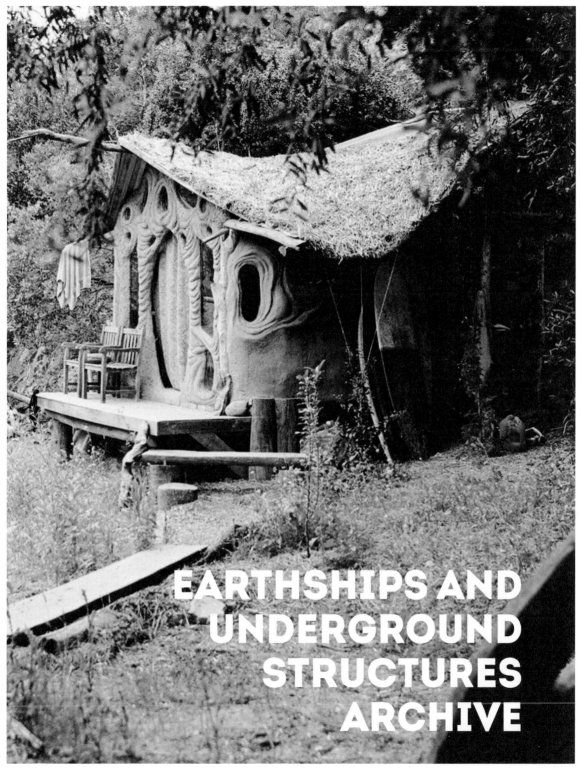

EARTHSHIPS AND UNDERGROUND STRUCTURES ARCHIVE

Cyrus Sutton | Ojai, California

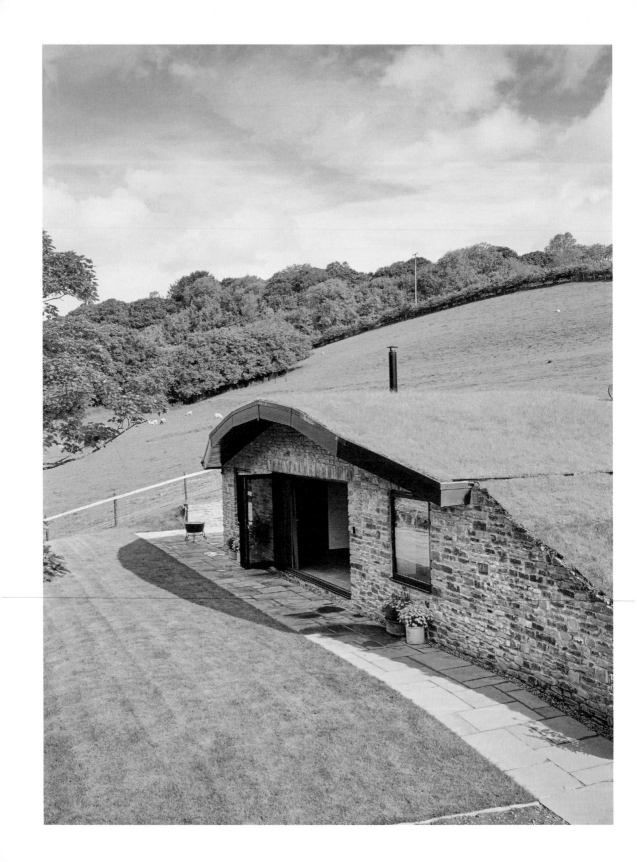

Amy and Tom Jones | *The Burrow at Dolassey Farm* | Powys, Wales, United Kingdom

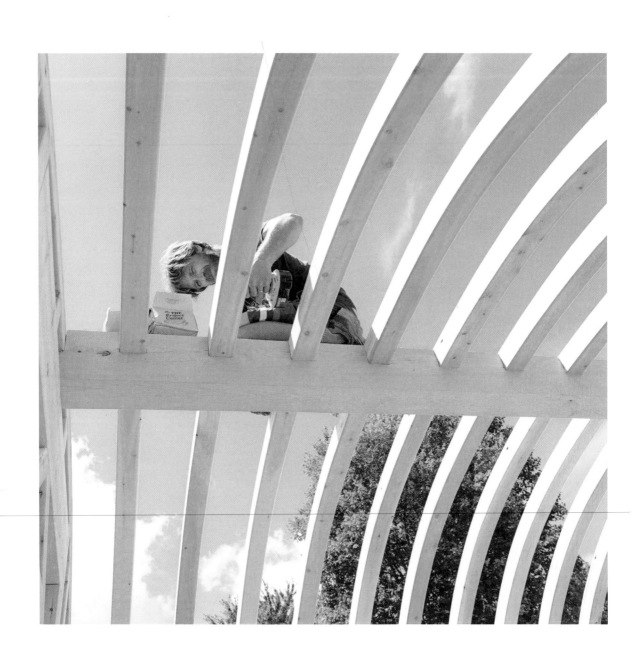

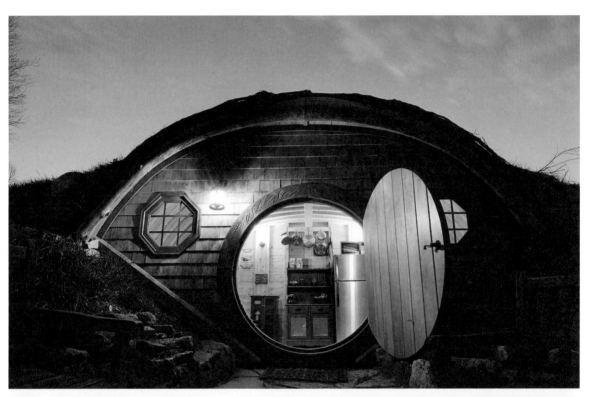

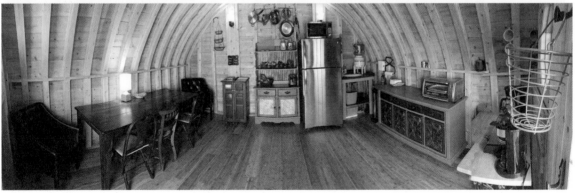

Jon Giffin | *Forest Gully Farms* | Fly, Tennessee

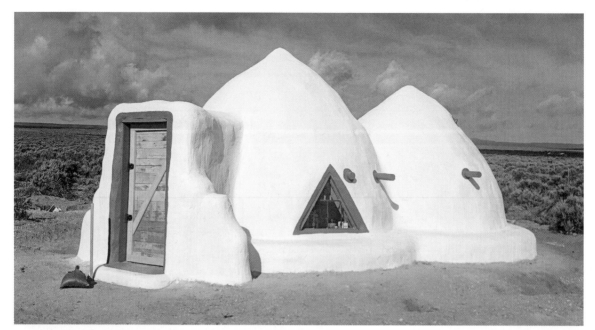

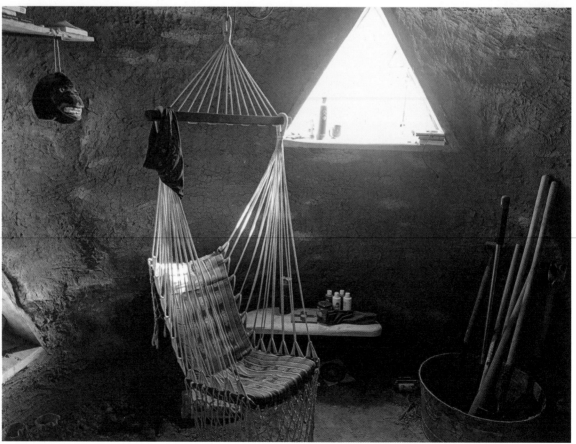

Jon Giffin | *Homey Dome* | Taos, New Mexico

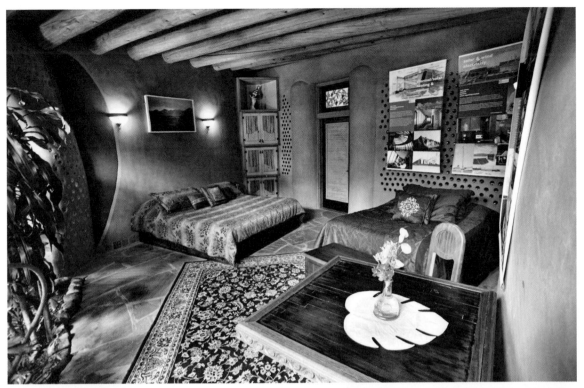

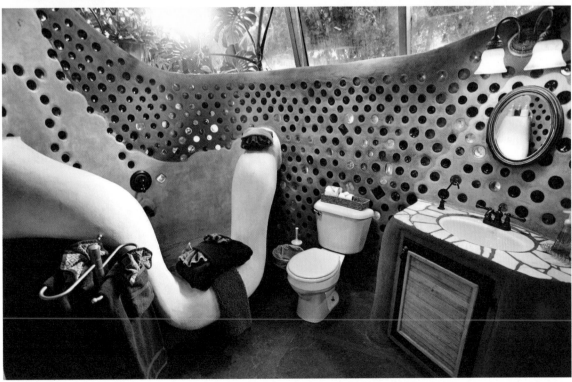

Jon Giffin | *Phoenix Earthship* | Tres Piedras, New Mexico

CHAPTER 4

SHIPPING CONTAINERS

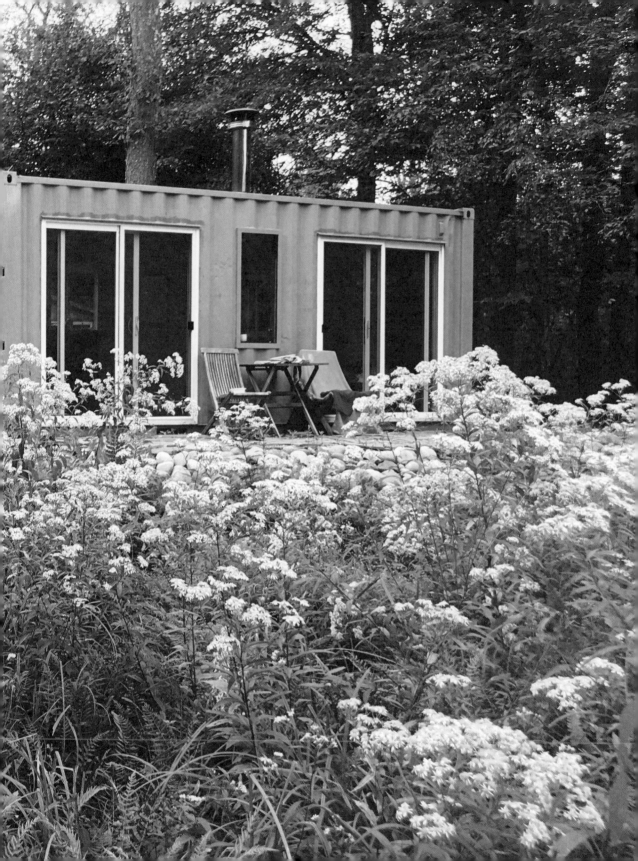

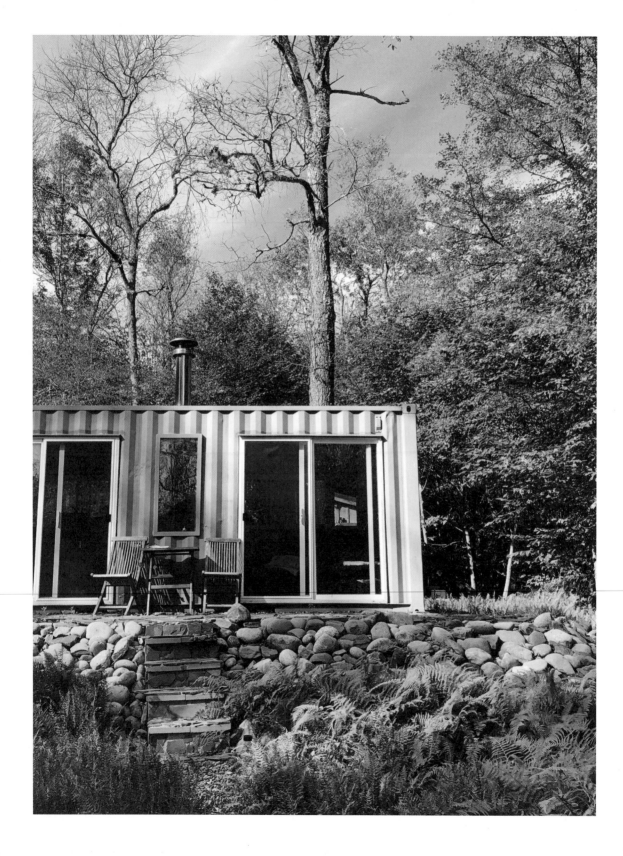

Chris Graham's Off Grid Shipping Container Getaway in Upstate New York

Chris Graham is a music producer living in Brooklyn, New York.

I've lived in New York for a long time. I've traveled and lived in other places, but I always end up coming back. I love the city, but it can be a very overwhelming and stressful place. So at a certain point, I thought to myself, "Okay, if I'm going to live here, how am I going to get out?"

When I first moved to New York, I got rid of my car. It was a great feeling. But it also meant I could only easily travel as far out of the city as the trains run. When I met my wife, she had a car. She moved to New York and decided to keep it so we could do some exploring. That really opened up the possibility of having a place outside the city, and we started thinking about buying property.

There's a lot of beautiful country close to New York City—the Adirondacks, the Catskills, etcetera. Our property is in Livingston Manor, in a little hamlet called Willowemoc, which is at the southeast edge of the Catskill Park, about 100 miles from New York City. We bought the parcel two years ago. We were always backpacking and camping in that area and we really loved it, so eventually we decided, "Okay, we can afford something up here, let's figure this out."

When we first decided to buy the property, we had all sorts of questions. How are we going to get up here? Are we going to come every weekend? Is it just going to be in the summer? Can we work from the Catskills? Can we build something?

We knew off the bat that we wanted something unique. When we bought the property, there was basically nothing on it—just a junked-out old truck and an abandoned trailer we had to have hauled off. So we were working with a blank slate. Originally, I was envisioning some sort of glamping situation. I was looking at canvas tents and tipis and micro cabins. I wanted something that would keep us comfortable, but without all the conveniences and luxuries of a vacation home or cabin. We knew we wanted it to be off grid, with solar power and composting toilets. We wanted something low-key, low-maintenance, and low-cost. Having a minimal impact was really important to both of us.

One day I was scrolling through Airbnb, looking for a place to stay for a few days while we visited the property, and I saw a shipping container house. It was a very simple design made out of a single container. I hadn't seen that before. I'd seen all the over-the-top shipping container cabins that people post pictures of—all stacked up and really high-end looking, almost like art pieces. But I hadn't seen anything like the place I saw on Airbnb. It was just an 8x20-foot container with two big sliding doors. I was instantly attracted to the simplicity of it, and I figured we should go stay in it and see what it was like.

We got up there, and as soon as we stepped through the door, I thought: This is good. This is what I want. So I contacted the guy who owned it and asked him who had built it for him. It turned out the builder was a guy named Michael and that he lived in Red Hook, Brooklyn, about a mile from my wife and me.

I decided to go see Michael and ask him some questions, but in the meantime, I did a little more research on shipping container homes. I wanted to learn more about them and see if it was the type of project we could do on our own. I quickly realized that there's a lot involved in getting a container ready to live in. For starters, there's a lot of metalworking. I can't weld or cut steel or do anything like that, so I decided that if this was something we ultimately decided to pursue, we were

going to have to hire a professional. I met with Michael and we talked, and he showed me some of the stuff he had worked on. His whole office in Brooklyn is built out of containers. He was very flexible and willing to work with us on the design, so we hired him on.

One thing I really liked about the container idea was that it could be done quickly. As soon as we got the property, I immediately wanted to spend as much time there as possible, so getting something built quickly was important to me. And it went really fast. From beginning to end, the whole process only took a few months. We closed on the property in November, Michael got started on the build in January, and we were all set up and ready to go by the summer.

The container is completely off grid. We've got a couple of battery-powered lights inside, and two rechargeable LEDs that are nice and bright. We have a solar system, but we've discovered there's not really that much we need electricity for. We hardly use it at all. We've got a

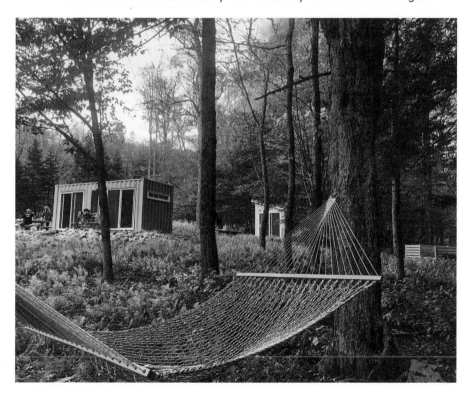

woodstove for heat. For cooking we use a camp stove that runs off a small propane tank. We've got a little sink for dishes and stuff, but there's no plumbing, none of that. There's a spring near our property, so we usually walk to the spring and fill up a big container of water.

The whole setup is very simple, and that was intentional. We never really wanted a fully functioning home. We wanted something one step up from camping. After all, we bought the property to be outside more—out in nature, away from the city. It's a 6-acre parcel right on the Willowemoc Creek, which is a famous fly-fishing river. There's so much stuff to do in the area. We wanted to make sure that we honored our intentions and didn't spend a fortune building some ritzy vacation home that would ultimately just encourage us to stay inside more.

One thing I never would have expected is that our social life has really blossomed in Willowemoc. A lot of young people have moved up north from the city—a lot of artists, some musicians. They come up to these small towns because it's so cheap and they can still access the city when they need to. For people doing freelance work, it's a really great option. I'm amazed by the number of people coming back out to the area.

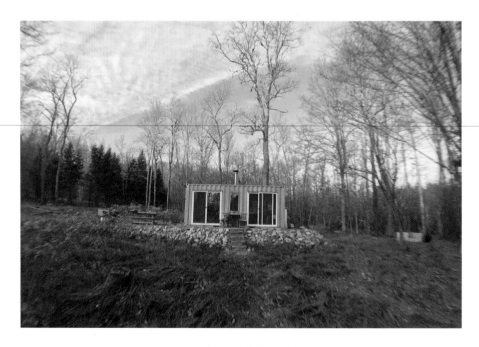

SHIPPING CONTAINERS ARCHIVE

Jon Wood | *The Hobbit House* | Rolling Hills Estates, California

Casey Tane | White Salmon, Washington

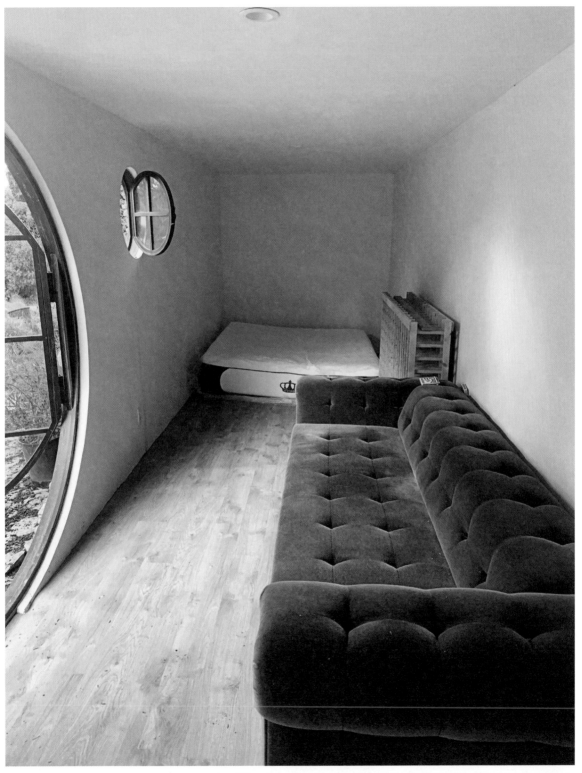

Jon Wood | *The Hobbit House* | Rolling Hills Estates, California

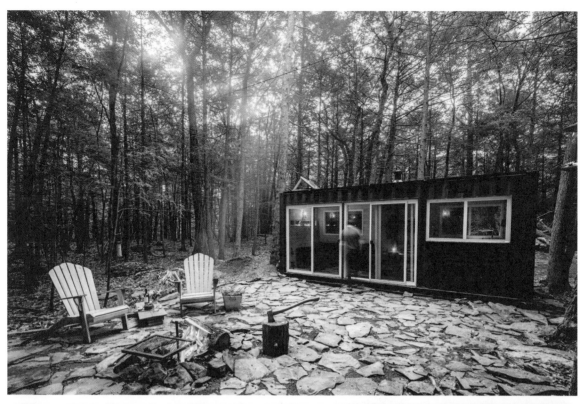
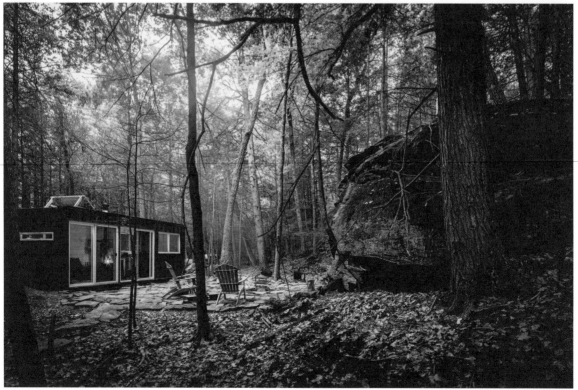

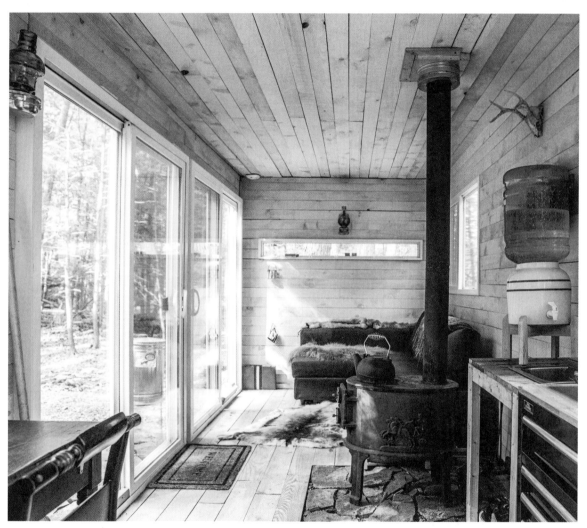

Mike O'Toole and Tim Gilman-Sevcik | *Contanium Cabins* | Hudson Valley, New York

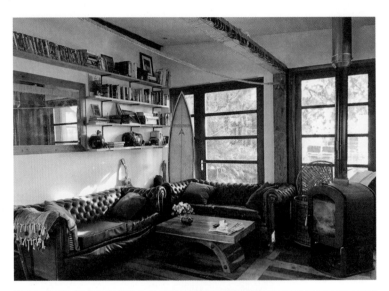

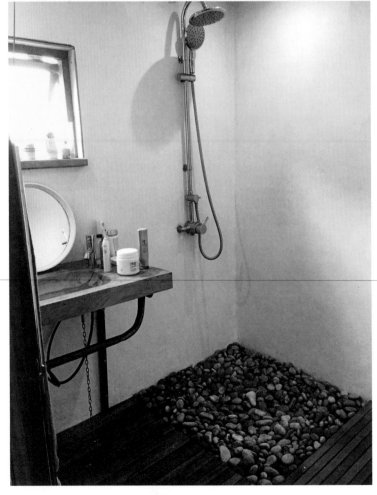

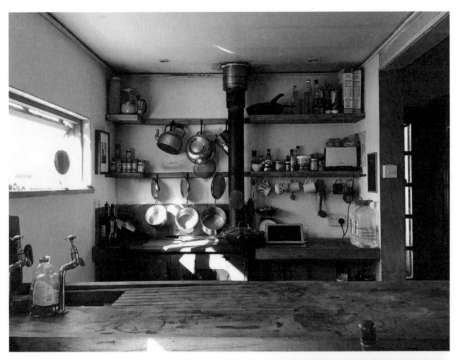

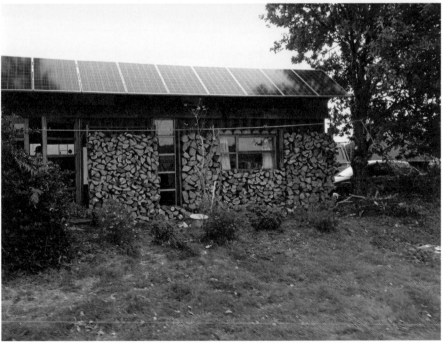

Rob Cox | *The Hedge House* | Dorset, United Kingdom

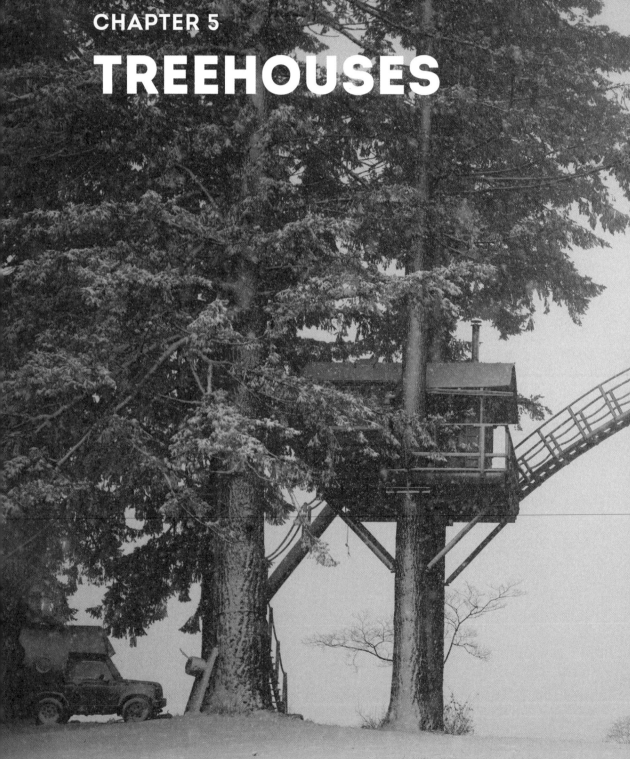

TREEHOUSES

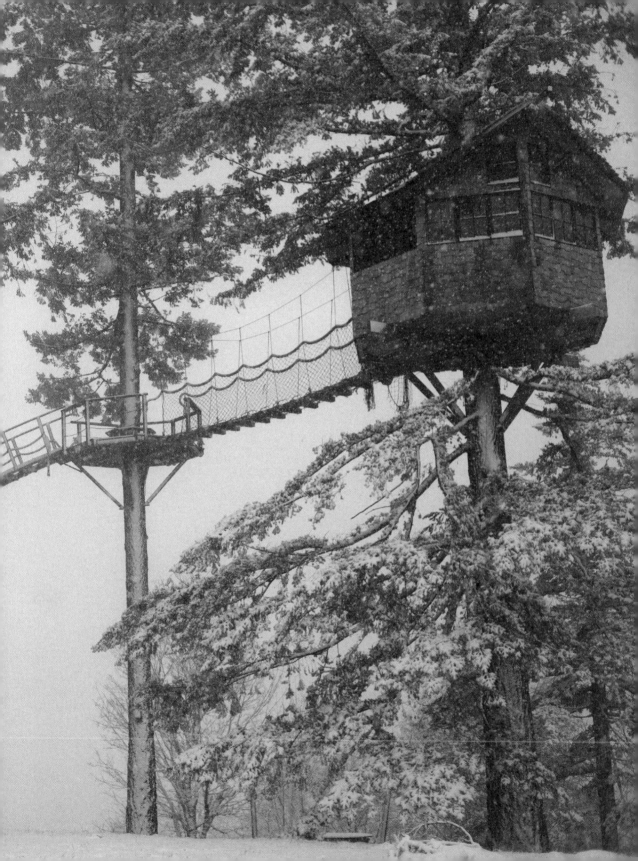

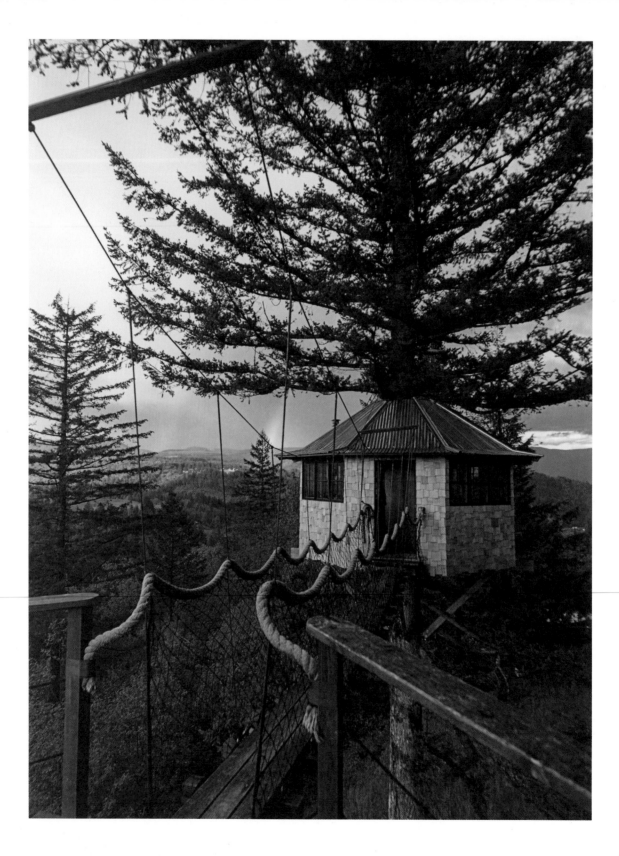

A Treehouse Colony in the Mountains of Washington

Foster Huntington is a photographer and filmmaker living in Skamania County, Washington.

I have answered the question "Why a treehouse?" hundreds of times. Each time I hear it, I grow increasingly puzzled, because I believe it to be self-evident. If you have to ask, you'll never understand. I believe it's important to surround yourself with an environment that instills a sense of awe and excitement about life. My treehouses remind me of what's possible, and the amazing experience I had building them with my friends and family.

For my friend Tucker and myself, building a treehouse fulfilled a childhood dream. As kids, we each built our own treehouses. Both of our families worked in construction, so we pilfered supplies from job sites and built our own small treehouses and platforms. During college, Tucker and I were roommates. We would nerd out talking about the treehouse colony in *Swiss Family Robinson* and build snow forts in the plowed snow at the edge of parking lots. Here was a chance to actualize these dreams.

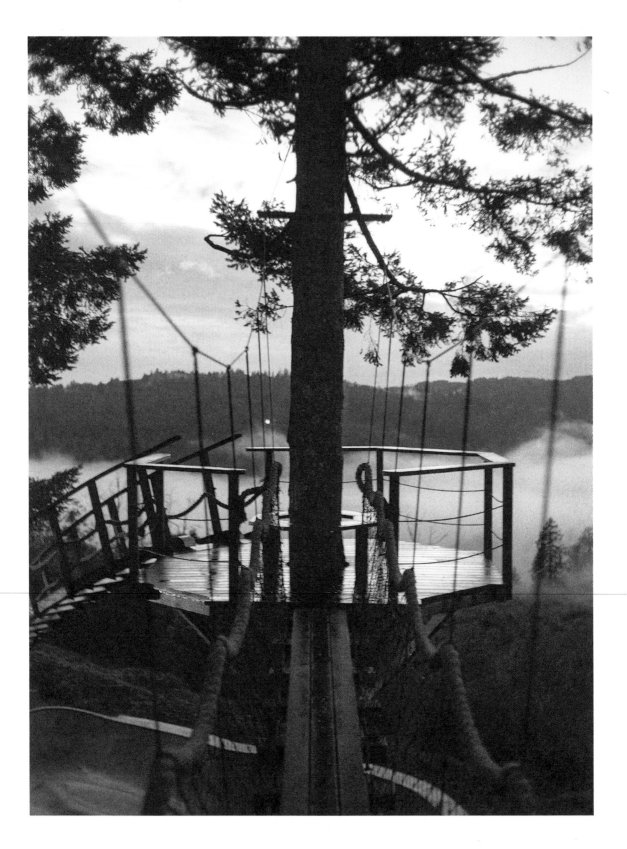

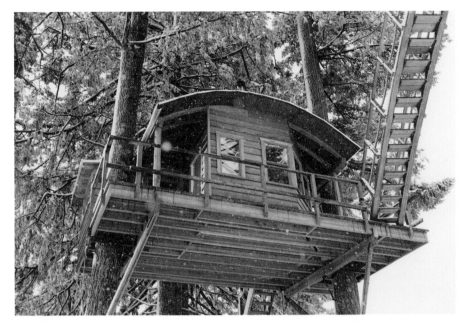

Prior to this project, Tucker had worked in construction and carpentry, building high-end projects in the Bay Area, but he'd never taken on a project of this scope. I grew up around builders, built furniture, and helped with my parents' houses, but I was also in way over my head on this project. With the gusto and naivety afforded to a couple of twenty-six-year-olds, we jumped in headfirst.

To build the foundation of the treehouses, we enlisted the help of legendary treehouse pioneer Michael Garnier. Living out of arguably the largest treehouse in the world, in southern Oregon, Michael runs a "treesort" called Out'n'About, and owns a business providing treehouse builders around the world with the mounting hardware necessary to build large structures without injuring the tree. Called the Garnier Limb, this hardware consists of a giant lag bolt–style anchoring system bored into the tree. Over time, the tree grows around this nickel-plated stainless steel screw the same way it would around a knot or limb, creating a very strong mount that does not hurt the tree.

Once the platforms were built and the bridges were roughed out, Tucker and I charged ahead, calling in friends and acquaintances from Maine to California to come and help us build. We combed Craigslist

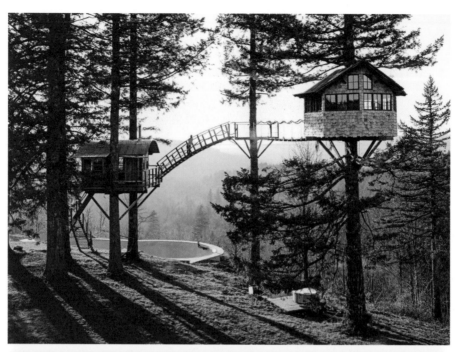

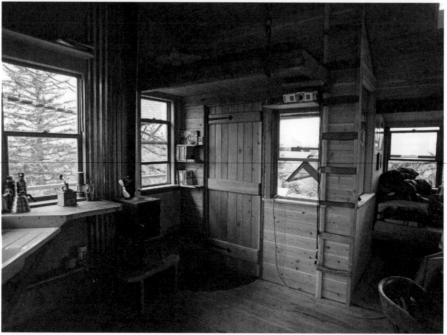

and local salvage yards in search of lumber for the build. With few exceptions, none of us were professional builders. We were more like a bunch of ragtag modern cowboys—a constantly rotating cast of characters living on the build site, sleeping in cars and old tents, smelling of campfires and spliff smoke, running on cheap beer.

One man's trash is another man's treasure. With the plague of condos sweeping through Portland like hordes of undead in a shitty zombie flick, places like the ReBuilding Center in North Portland were flooded with salvaged vertical-grain Douglas fir and cedar siding from old Victorian houses torn down and replaced with modern concrete-and-fiberboard structures.

We bought beautiful old-growth redwood and cedar for the same amount we would have paid for new lumber in a big-box store. Working around the occasional hundred-year-old nail, we framed the treehouses and sided them with this wood. On a tip from a friend, I bought windows from failed luxury houses that halted building in the middle of the 2008 housing crisis. For the handholds for the bridges, we used a tugboat line

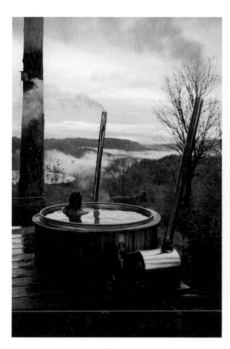
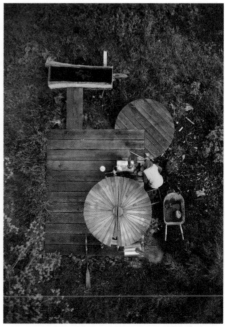

from a tugboat that hauled loads up the Columbia River. For the roofs, we used galvanized metal siding.

As anyone who has built their own dwelling can attest, the tree-houses will never feel finished to me. They are a work in progress, and I am constantly changing bed layouts, improving hangout spaces, and finding new ways to manage firewood. Every time Tucker comes back for a visit, we jump into some improvement or modification. When we were in the middle of the build, chasing the seasons to finish before snowfall, I couldn't wait for it to be over so that I could move in. Now I look back on the times I spent building the treehouses with my friends as some of the happiest of my life.

Throughout the pages of this book, you'll see a handful of different interpretations of the wood-burning hot tub. It's incredibly simple, yet never fails to bring a gigantic smile to the people that go through the hours of fire preparation and tending to bring the water up to heat. More than any other feature of the Cinder Cone, my property in the Columbia River Gorge, the wood-burning hot tub has brought joy, inspired great conversations, and provided respite from the terrible midwinter weather of the Northwest.

An article in *Mother Earth News* turned me on to the Chofu stoves-style wood-burning hot tub, and also the idea of using a readily available galvanized steel stock tank for the tub. The Chofu stove sits outside the tank and uses a system called thermal siphoning to heat the water. Cold water enters the stove via a pipe from the bottom of the tub, circulates around the firebox, warms up, and then exits through a tube at the top of the stove. The slight displacement of warm water on top of the cold water forces the cold water back into the stove, and the water heats up gradually as the cycle continues.

I took *Mother Earth News*'s recommendation for tub size to heart, but decided to use two stoves with the idea that it would heat the tub twice as fast. To make the stock tank more rigid and aesthetically pleasing, we wrapped it in 1x4 cedar fence posts that I found on the cheap at a local lumberyard. The two-stove theory worked and depending on what type of wood we burn, the tub takes anywhere from two and a half to four hours to get piping hot.

For a heat-trapping lid, we cut a piece of two-inch rigid foam to fit the tub and covered it with tongue-and-groove cedar. We've fired up the hot tub in every month of the year. Living at 1,100 feet in the Pacific Northwest, nighttime temperatures can get down into the fifties even in July. During the winter the hot tub really shines, punctuating the cold snaps and snow with a ritual that brings people together. I would recommend a tub like this to anyone with the space, whether it's a suburban backyard or an off grid cabin in the Rockies.

MATERIALS

2 Chofu stoves
2 (8-foot) sections of 4-inch stainless steel pipe
1 (390-gallon) stock tank
3 Douglas fir 1x12s in 8-foot lengths
1 box of wood screws ($5/16$ inches x 5-$1/8$ inches, GRK Fasteners)
6 old railroad ties for the foundation
8 bags of 90-pound quick concrete
optional: cedar 1x4s for wrapping the stock tank
(Note: This is purely an aesthetic decision and is very time-consuming.)

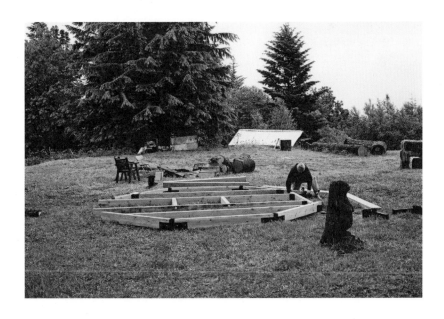

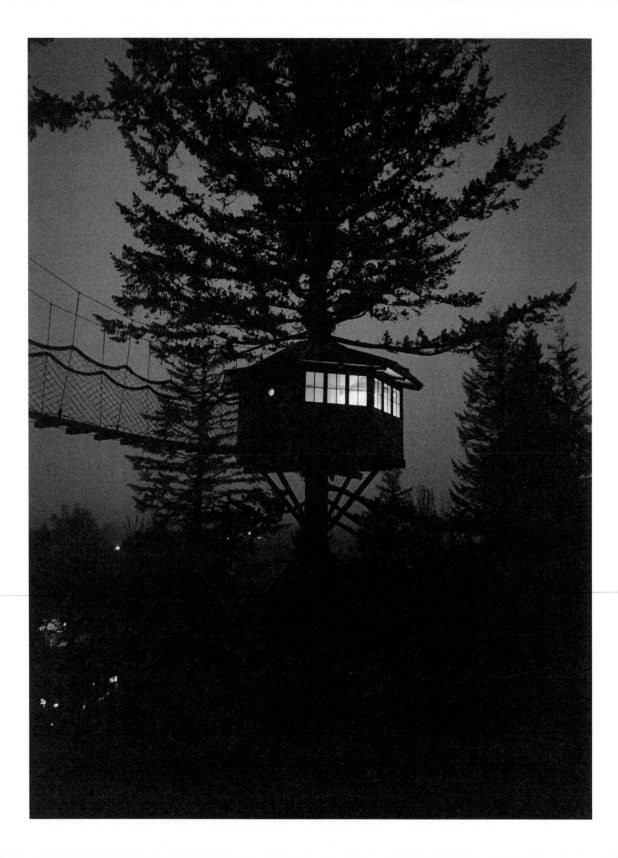

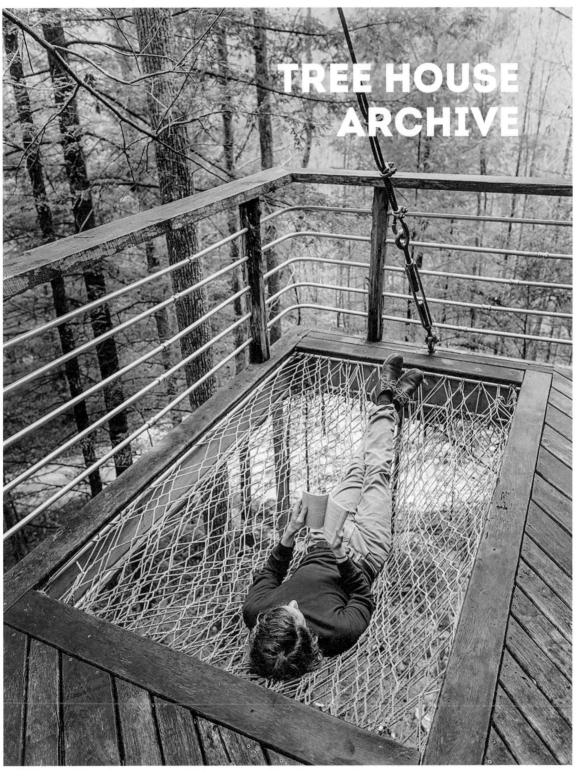

TREE HOUSE ARCHIVE

Django Kroner | *The Observatory Treehouse* | Red River Gorge, Kentucky

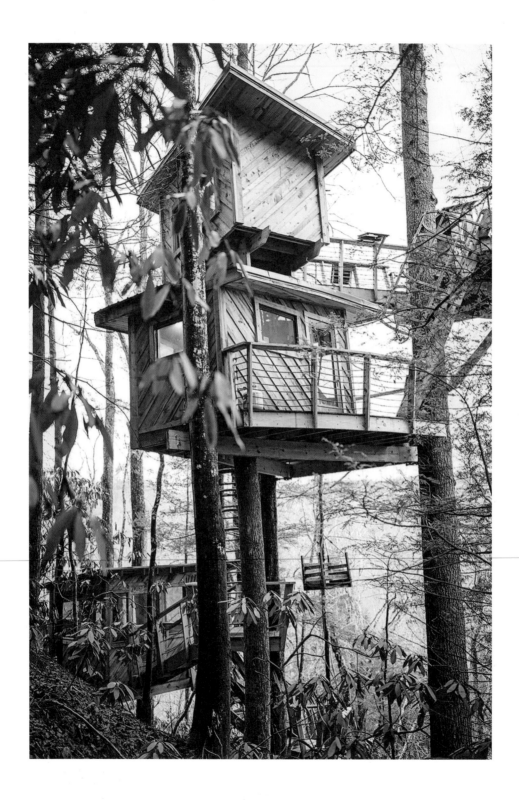

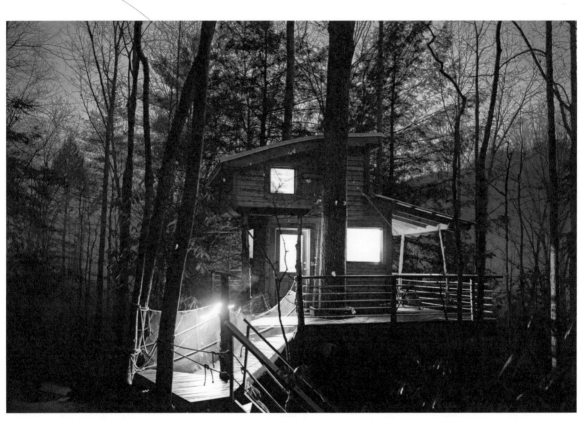

Django Kroner | *The Observatory Treehouse* | Red River Gorge, Kentucky

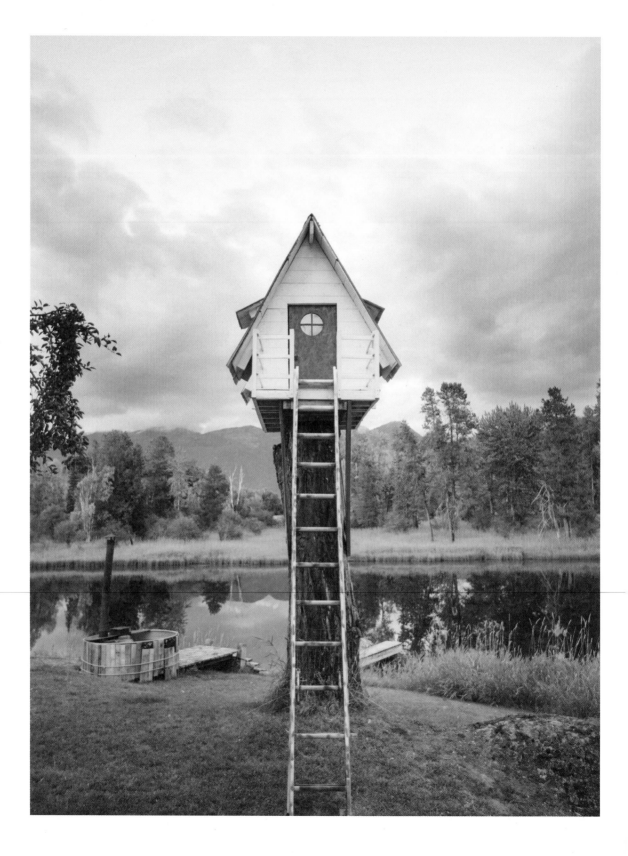

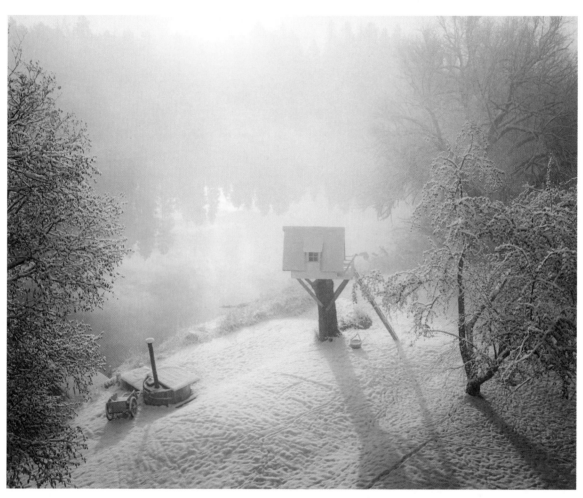

Isaac Johnston | *River Treehouse* | Bigfork, Montana

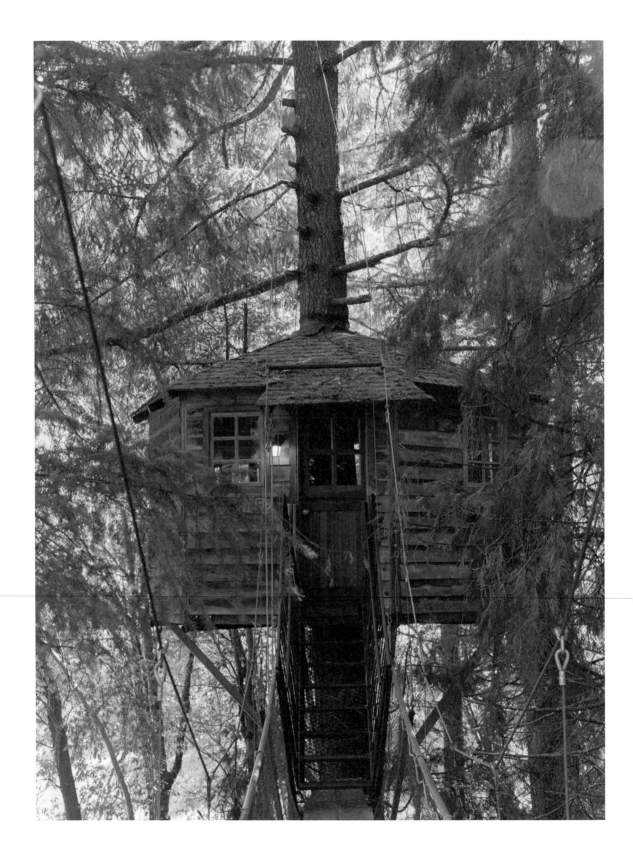

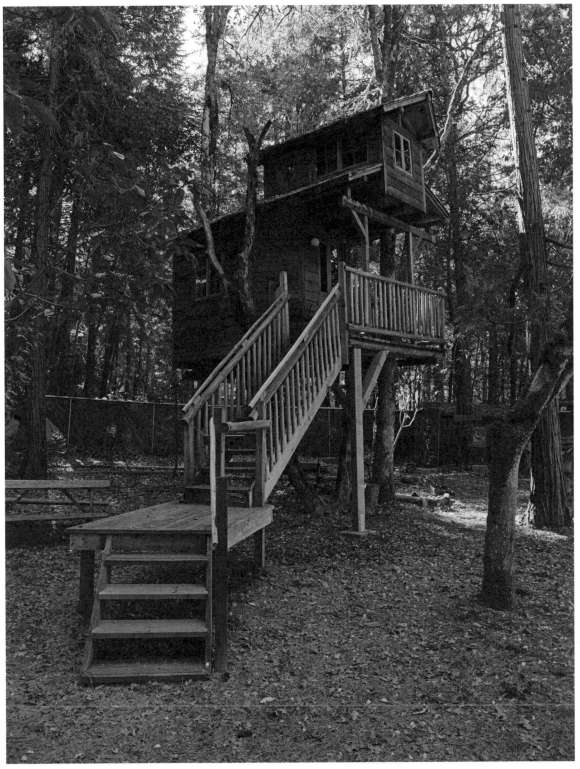

Michael Garnier | *Out'n'About Resort* | Cave Junction, Oregon

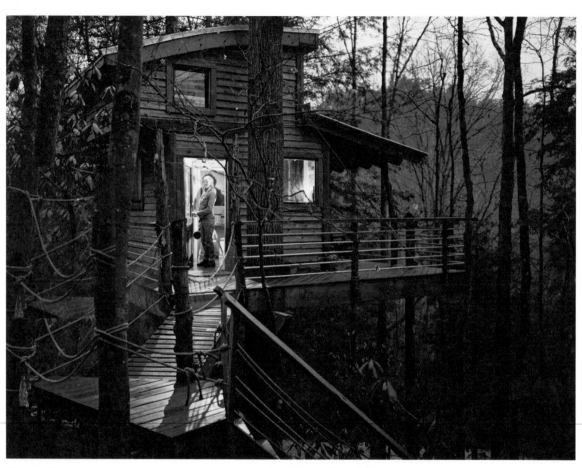

Django Kroner | *The Observatory Treehouse* | Red River Gorge, Kentucky

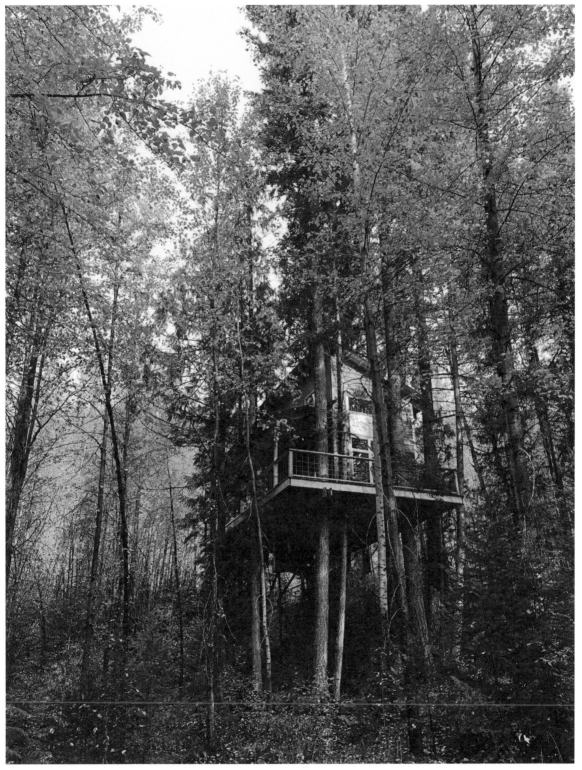

Howard Fenton and Elaine Sol | *Shaky Knees* | Youngren Creek, British Columbia, Canada

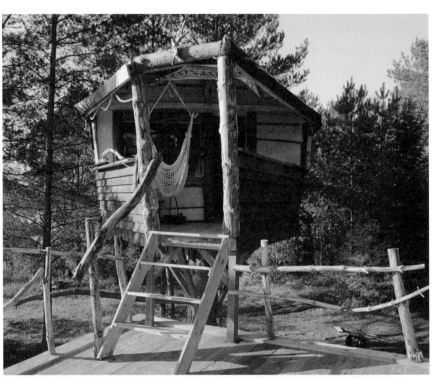

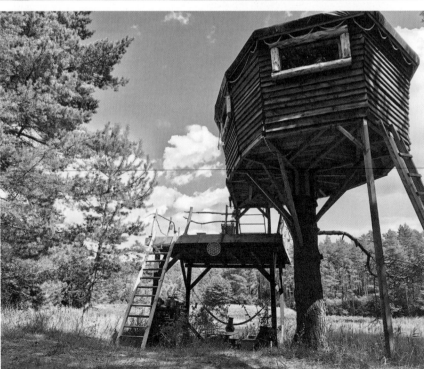

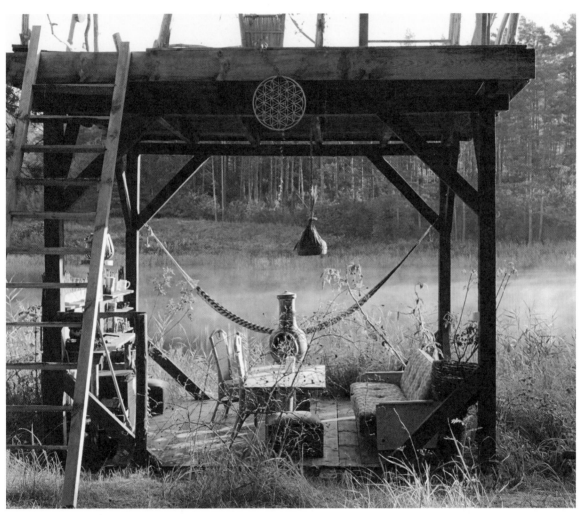

Adam Ram | Silent Lake, Poland

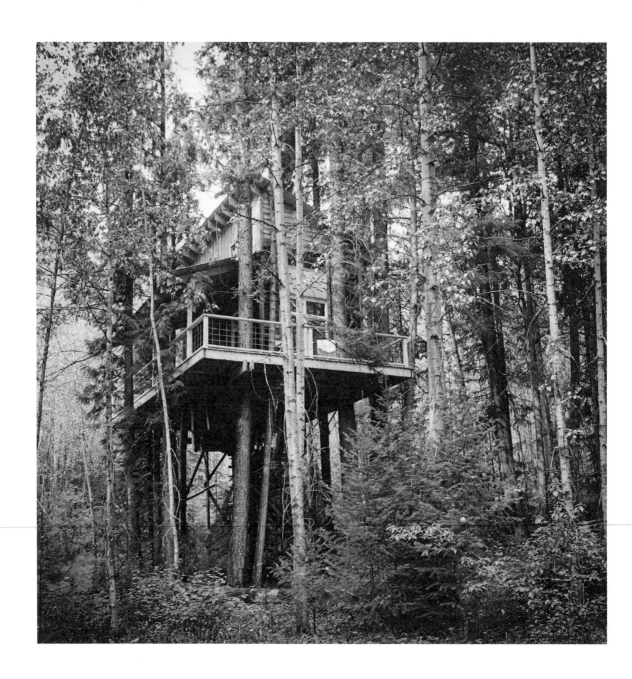

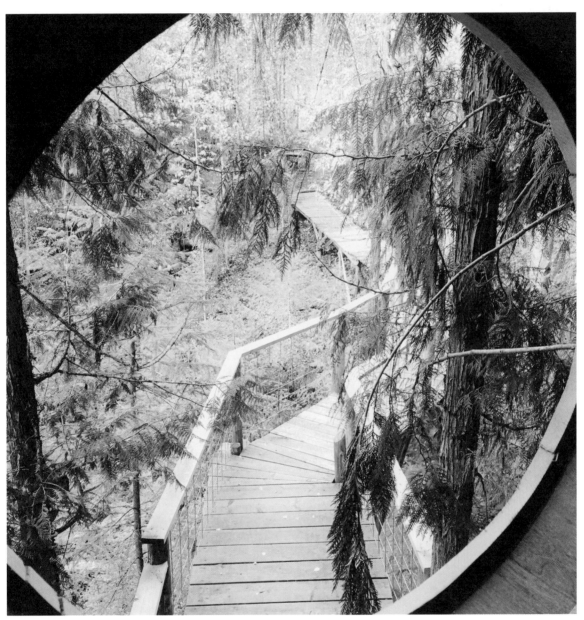

Howard Fenton and Elaine Sol | *Shaky Knees* | Youngren Creek, British Columbia, Canada

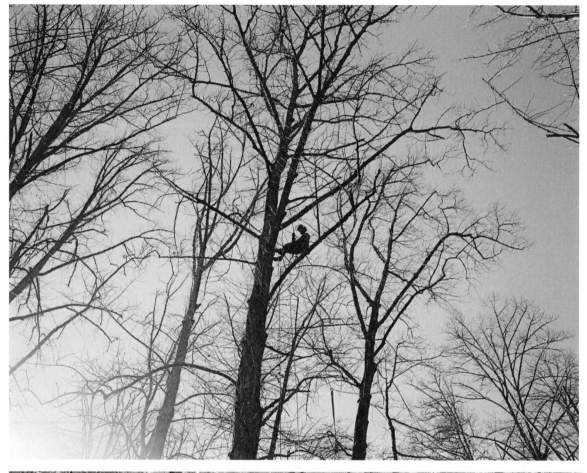

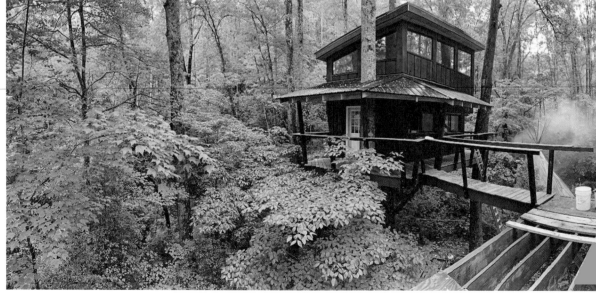

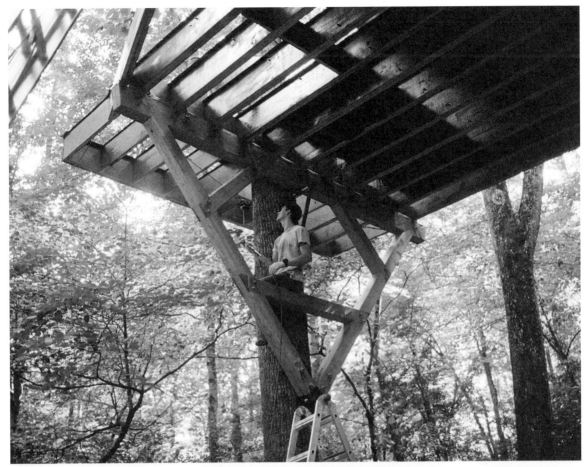

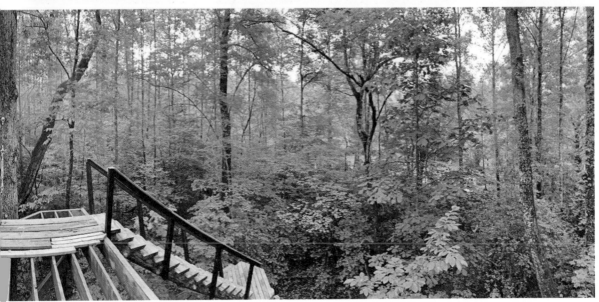

Forest Woodward | North Carolina

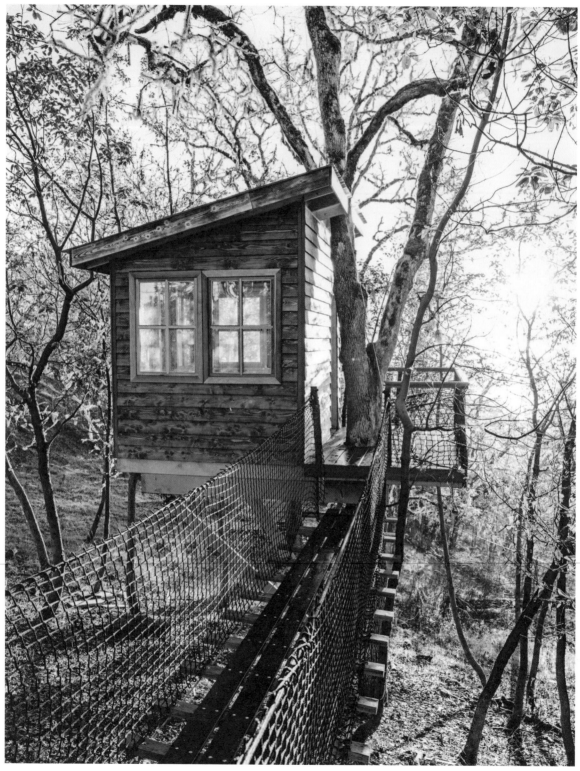

Hunter Bancroft | *Mary Crossfield Ray of Sunshine Treehouse* | Roseburg, Oregon

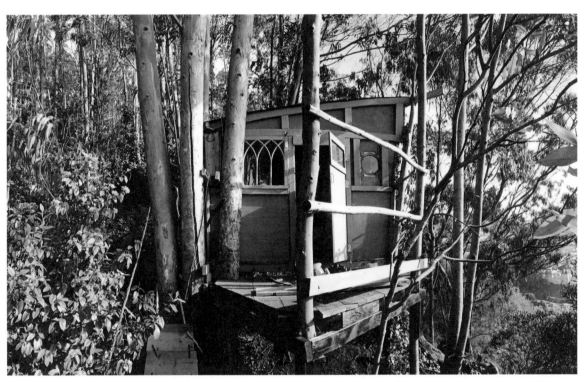

Stevie Page | San Francisco, California

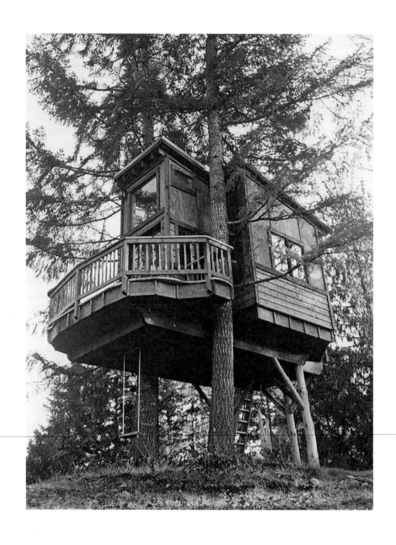

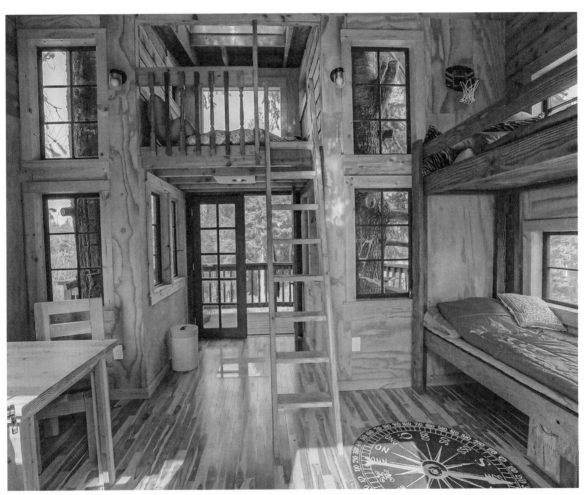

Michael Murphy | Yelm, Washington

CHAPTER 6

TINY HOMES

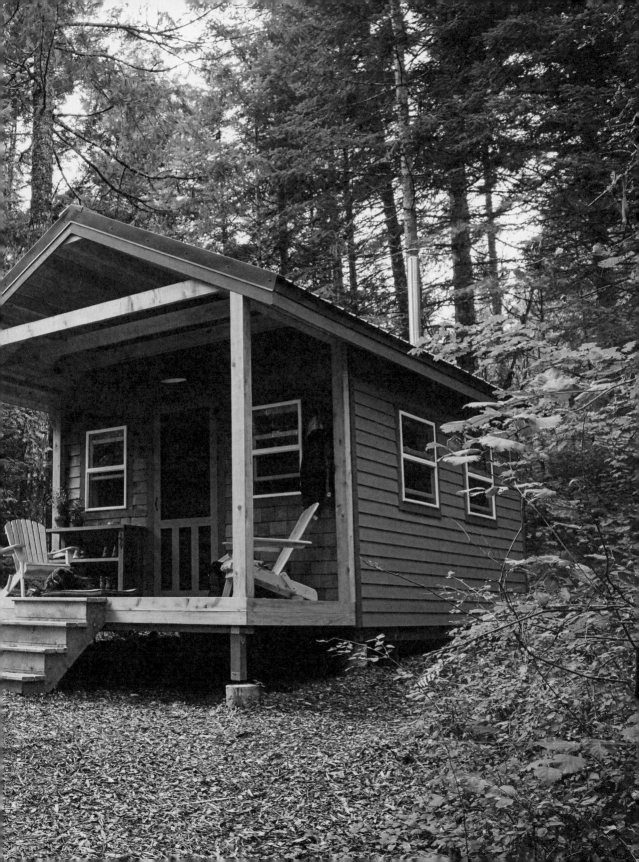

Building a Dream Tiny Home with Tucker Gorman

Tucker Gorman is a builder and artist living in Oakland, California.

In 2012 I moved to California with my buddy Greg in my fully packed Ford Aerostar. We were working and living out of the van for a couple months until we ended up renting a 21-foot sailboat. This wasn't planned—it just happened. It was tight quarters, but at that point it was our best option. We were bootstrapping our woodworking business and money was tight. That was when California was in the depths of a drought and the weather was perfect every day, so living on a boat was dreamy. We lived like sardines for six months before I moved onto a 28-foot sailboat I had bought for $1,000.

When I describe living in a marina to people, there are a couple of things I compare it to. One is a glorified trailer park. The other is a campground. It's quiet, unlike anywhere else in the city. You don't have buildings around you—it's just open sky and fresh air. It's a nice way to live, but definitely bare-bones. A bachelor's lifestyle.

The grittiness of boat life can get old after a while. The winters might get challenging, even in California. The cold isn't so bad; it's the moist cold and the constant threat of leaks and mold that make living on a boat in the winter difficult. My woodstove helped. But I do recommend that anybody with the opportunity try living on a boat for

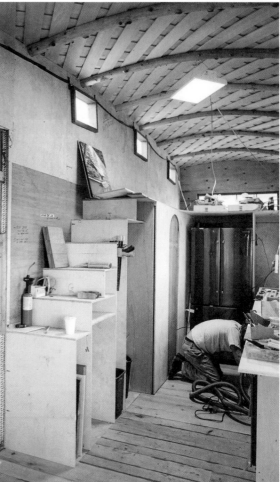

some period of time. It's a really special experience to be so connected to the water.

After three years of solo boat living, I was offered a room in a house with a backyard and indoor plumbing. I gave it a shot, but I missed living entirely on my own terms. A year in, an opportunity came up to rent a 150-square-foot office space connected to my woodshop. It dawned on me that I could live there as well. The rent was next to nothing, and I had my own space. All of a sudden, two years passed. That's often the way these things go.

My housing credo has always been to find the cheapest way to live well. If you can *keep your overhead low*, you'll likely have more freedom and flexibility. You'll be able to pivot and make decisions unencumbered

by life's usual entanglements. You don't have to work as much to make ends meet. In general, I'd like to encourage people to be resourceful and think creatively about their living situations. Think outside the box.

Simplification is critical to alternative living. A stripped-down life is not for everyone, but it's great if you can make it work. Sure, there are sacrifices you have to make. Sometimes there's no shower, there's no running water, there's no flush toilet. But if you do your time, hopefully you're still happy and can squirrel away some money. If you're willing to deal with the discomforts, eventually you may get to a point where you're living more comfortably. Maybe that comes in the form of building your own place.

Recently I was told I had to move out of my office space (aka "The Tiny Room"). I was about to get married, and that room wasn't sustainable long term anyway. A lot of contemplative thought about the future was happening. My wife, Liza, and I wanted a more permanent space, intentionally designed and suitable for a small family. I'd hoarded a lot of nice materials from my work as a builder, and it was finally time to use them.

I bought a 22-foot trailer and dreamt up our ideal home. With a loose vision and a belief in evolving design, I enlisted friends to help with the build. Almost a year later the house is still under construction, due largely to an overzealous attention to detail and complicated design. I find that designing on the fly results in a more thoughtful finished product, even though it usually takes longer and is more expensive. I think it's worth it. I find that letting ideas incubate usually leads to better results.

A problem I see with small living spaces is that most of them are really cramped. They have low ceilings or a loft with limited space above and below. They often make people feel claustrophobic. To avoid this, I decided on a voluminous design, maxing out the highway-legal width and height. The bedroom is a pit that cantilevers off the back, with room for a king-size bed. The roof is high and curvy, inspired by covered wagons, gypsy wagons, and boats. It's still possible to create coziness without compromising the sense of openness. Nooks, alcoves, and perches work great.

Even if a space feels big at first, once you start filling it with stuff, it's going to shrink rapidly. Finding creative storage solutions is important. For instance, we're installing shallow drawers under the lower kitchen cabinets, behind the toe kick. Unnecessary? It probably is if you live in a full-size house. In our case, every inch counts. But even full-size living will still inevitably force you to prune down your belongings or store them elsewhere.

The essential components of the house are now complete, and we're moving in to get a better feel for the space before making more design decisions—paint colors, types of interior wood, storage configurations, furnishings, etc. I find that if you make decisions in order of necessity, the best solution for the next thing often presents itself. You have a more complete picture to inform the rest of the structure. I'm a big proponent of mocking things up. See how they look and feel before you commit. While this method can be painstaking, it is also fun and inspiring. At the end of the day, that's what it's all about.

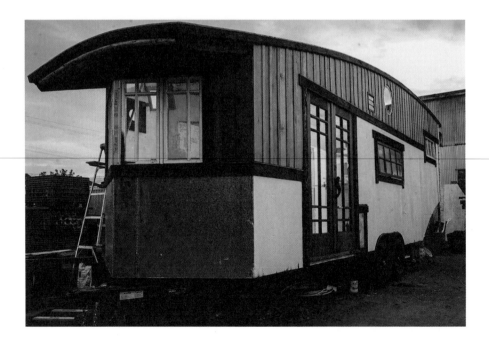

TINY HOMES ARCHIVE

Carey Quinton Haider | *Green House* | Portland, Oregon

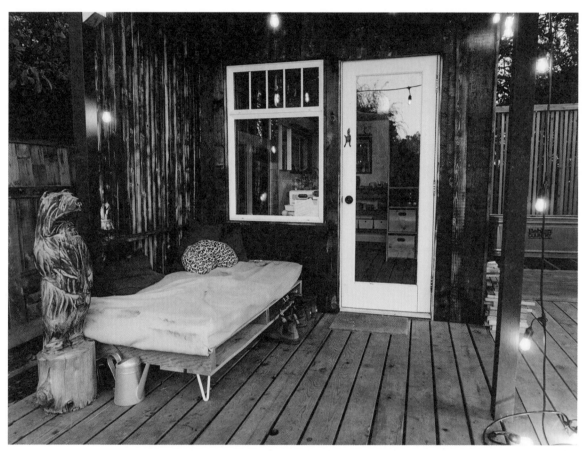

Brett Higson and Mackenzie Duncan | *T-House* | Victoria, British Columbia

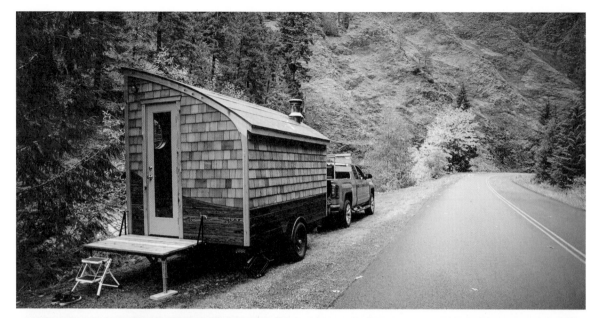

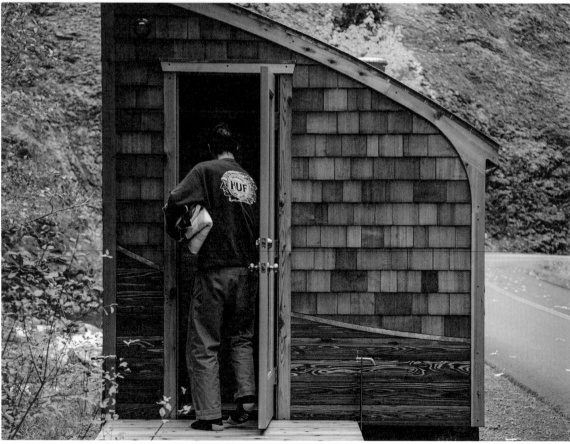

Joey Pepper | *Alma Saunas* | Portland, Oregon

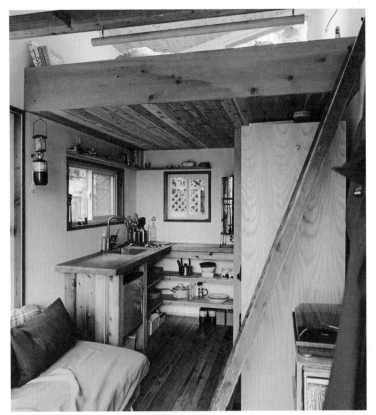

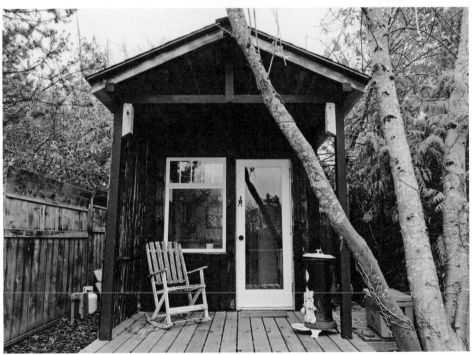

Brett Higson and Mackenzie Duncan | *G-Suite* | Victoria, British Columbia

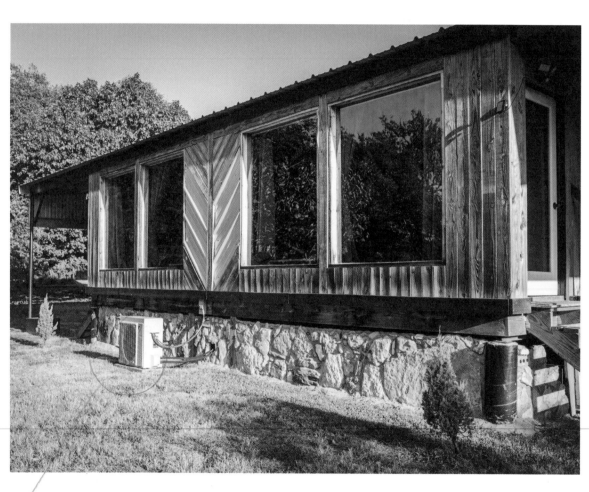

Vderstand
This—ant,
'Colorinterg?'
?

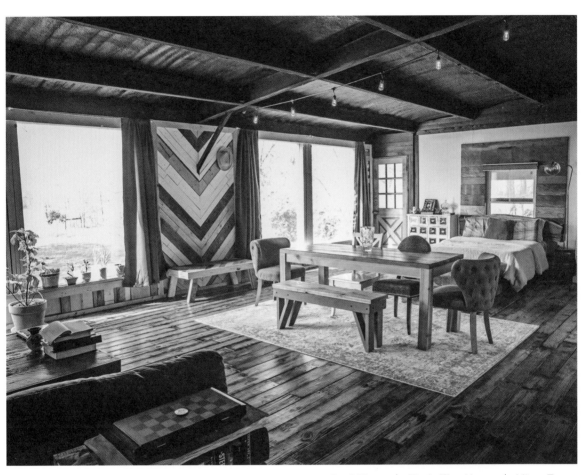

Paul Risse | *Kinda Tiny Home* | Hico, Texas

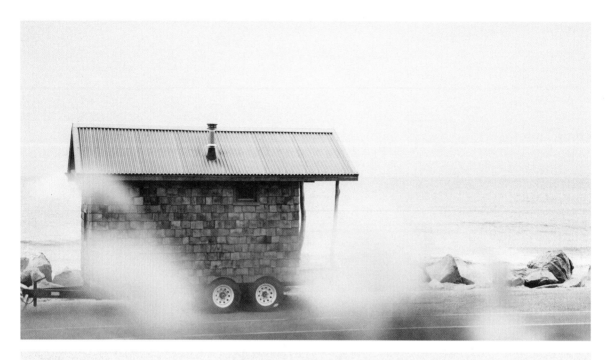

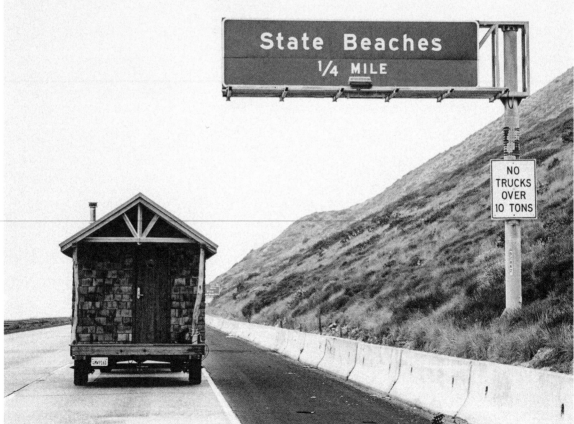

Ryan O'Donnell | *Acorn* | Ojai, California

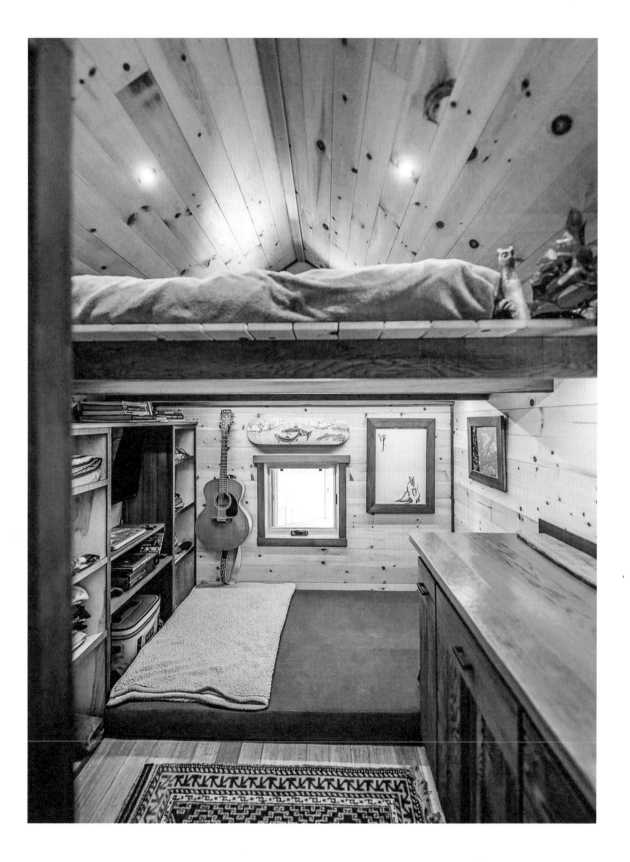

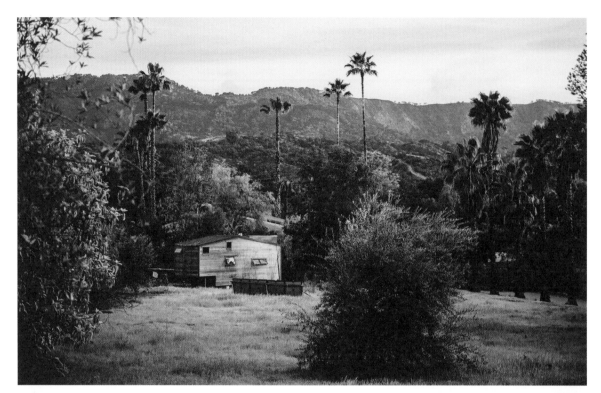

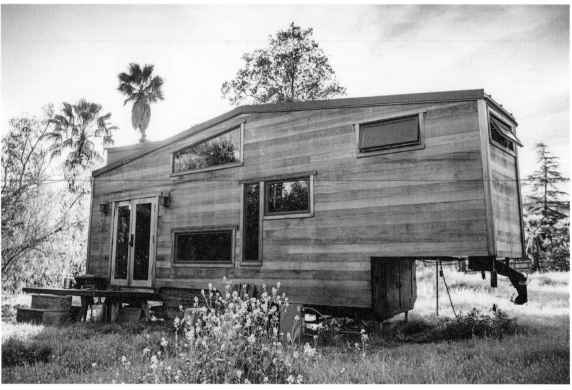

Ryan O'Donnell | *Los Padres* | Ojai, California | Builder: Sage Stoneman

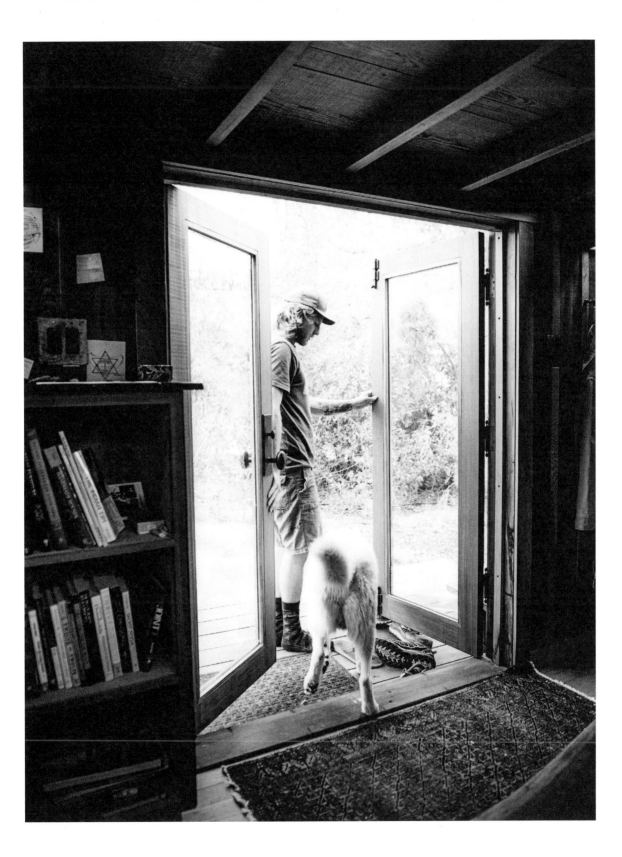

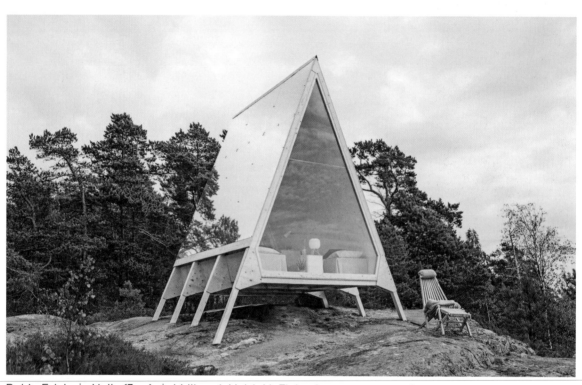

Robin Falck | *Nolla (Zero)* | Vallisaari, Helsinki, Finland

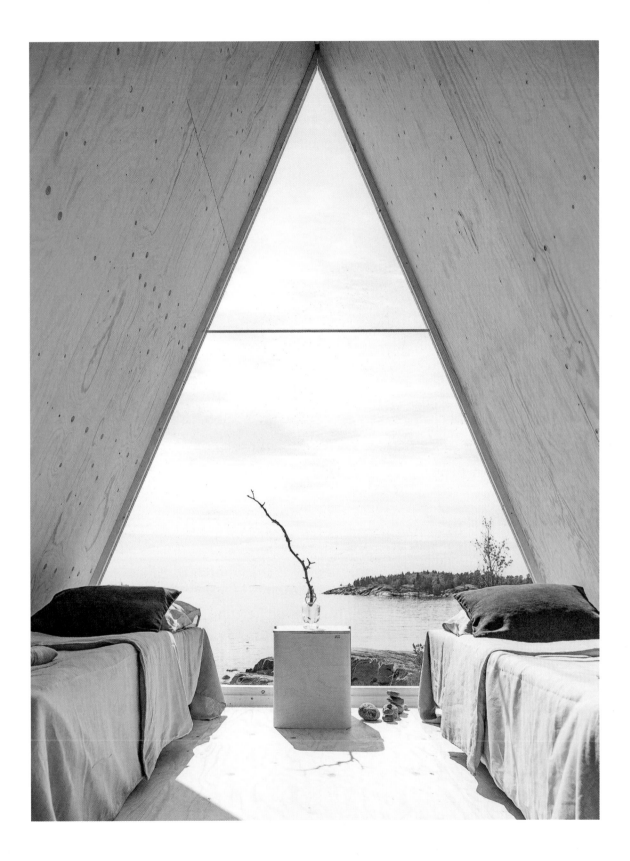

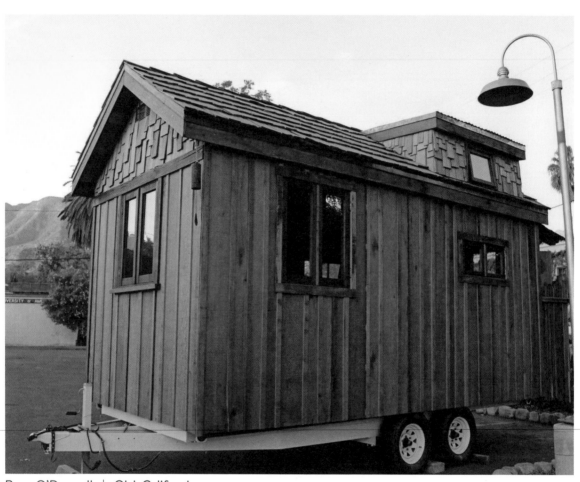

Ryan O'Donnell | Ojai, California

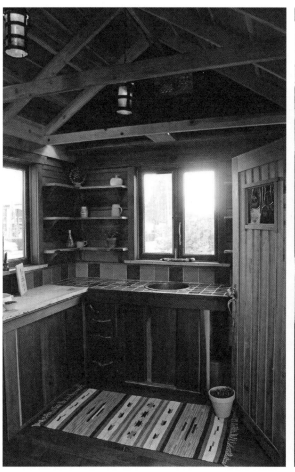

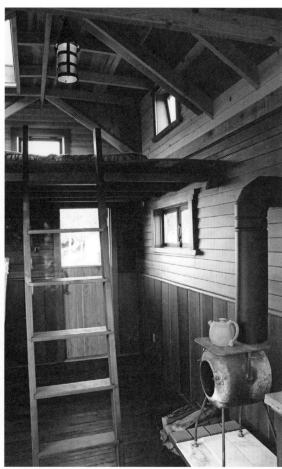

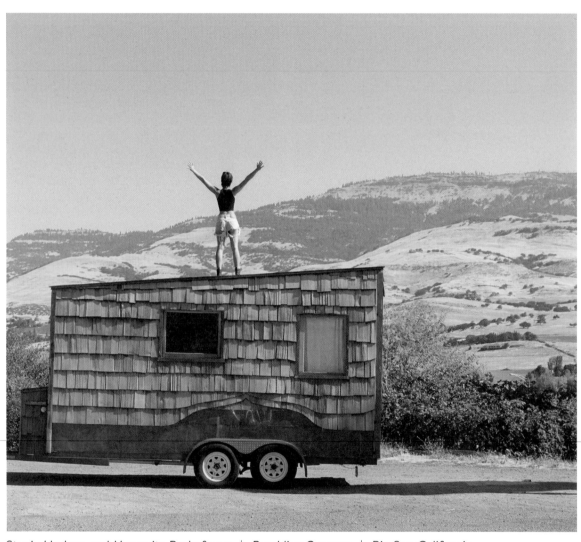

Stevie Hudson and Margarita Prokofyeva | *Rambling Caravan* | Big Sur, California

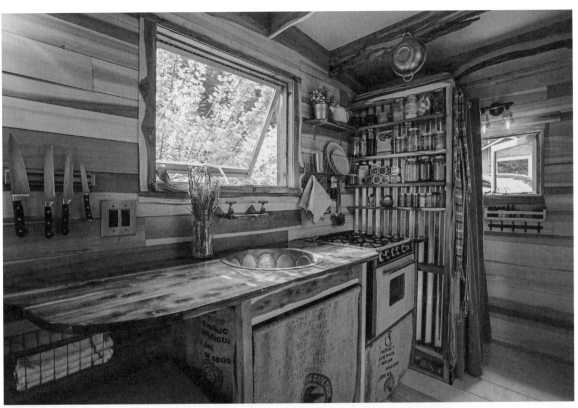

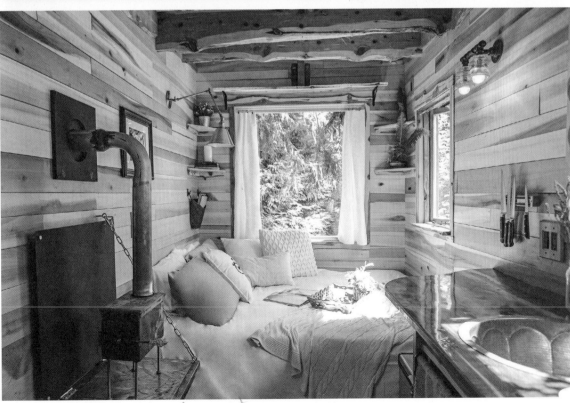

elevated

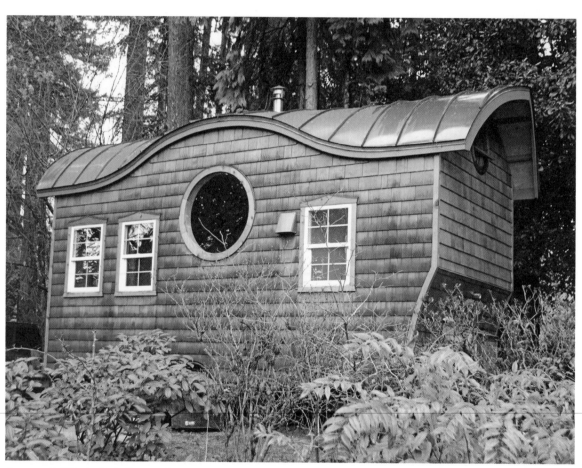

Jeremy Tuffli | Oak Grove, Oregon

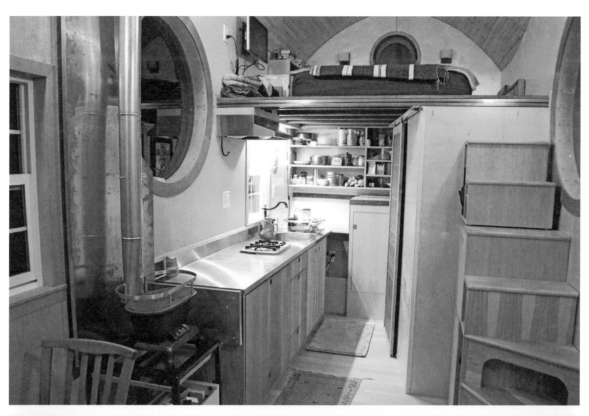
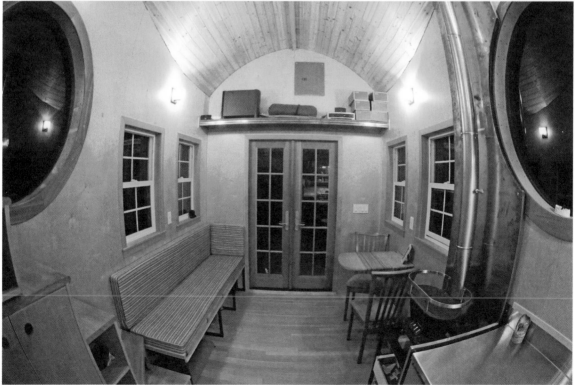

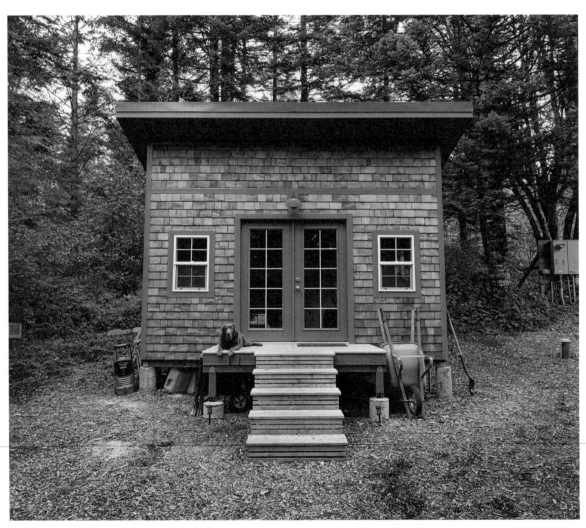

Jack Potter | *Elk Crossing* | Columbia River Gorge, Washington

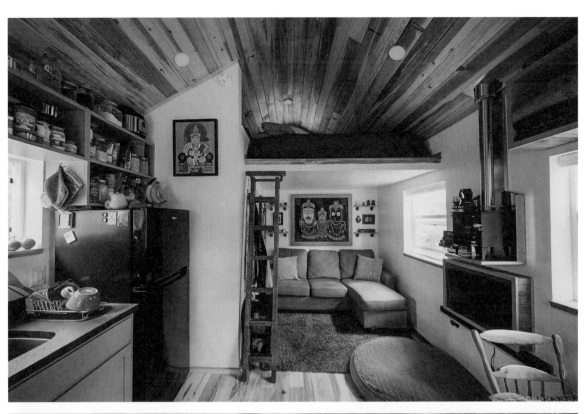

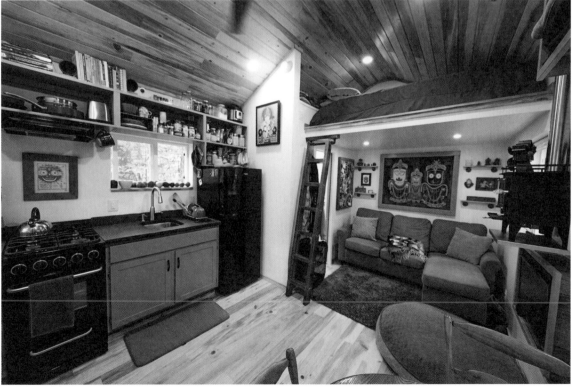

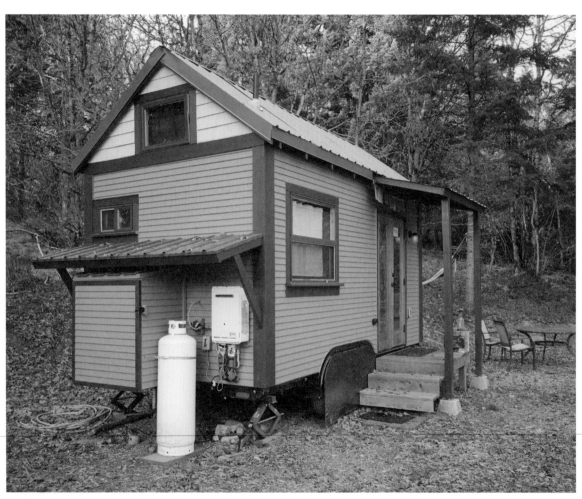

Scott Cushman | Underwood, Washington

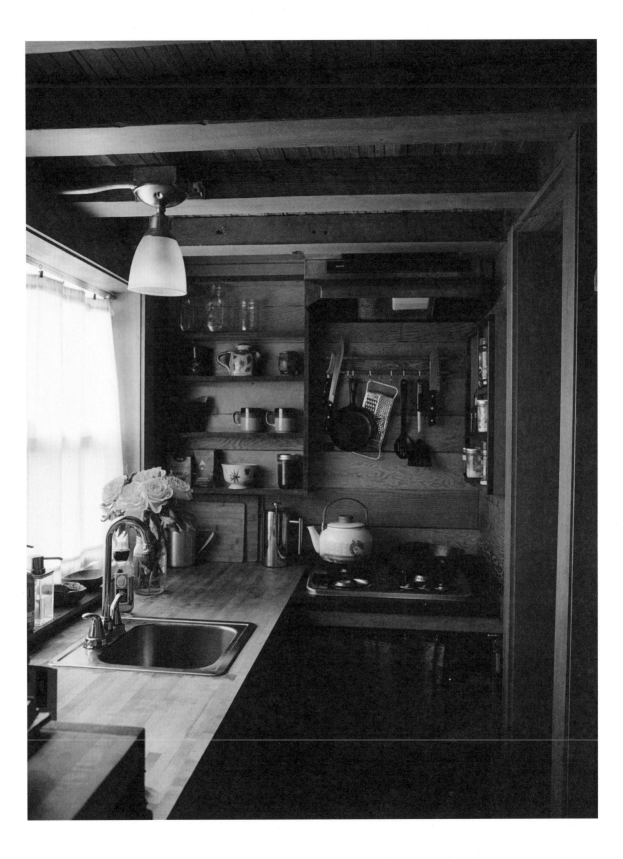

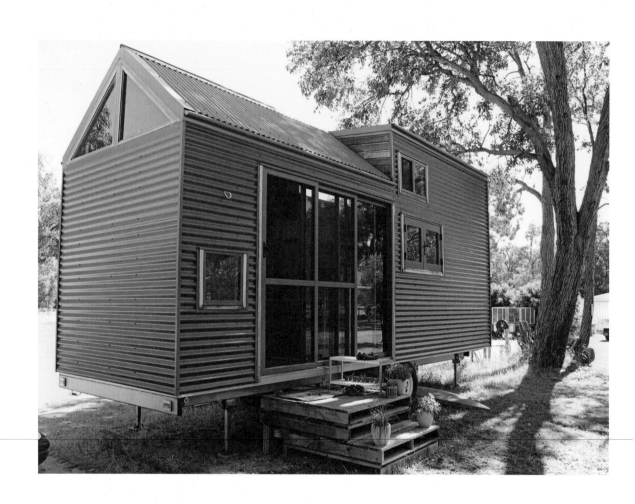

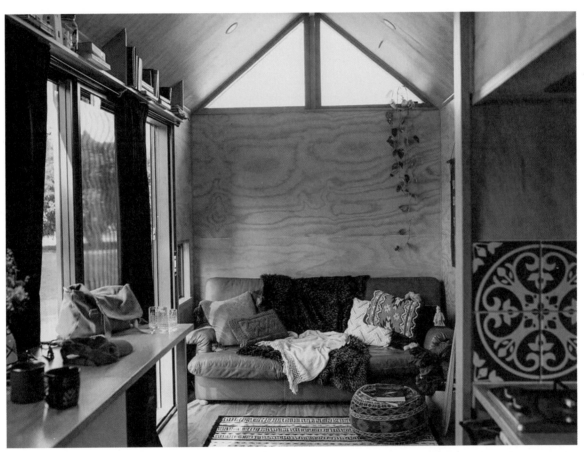

Hannah Mettam | Perth, Australia

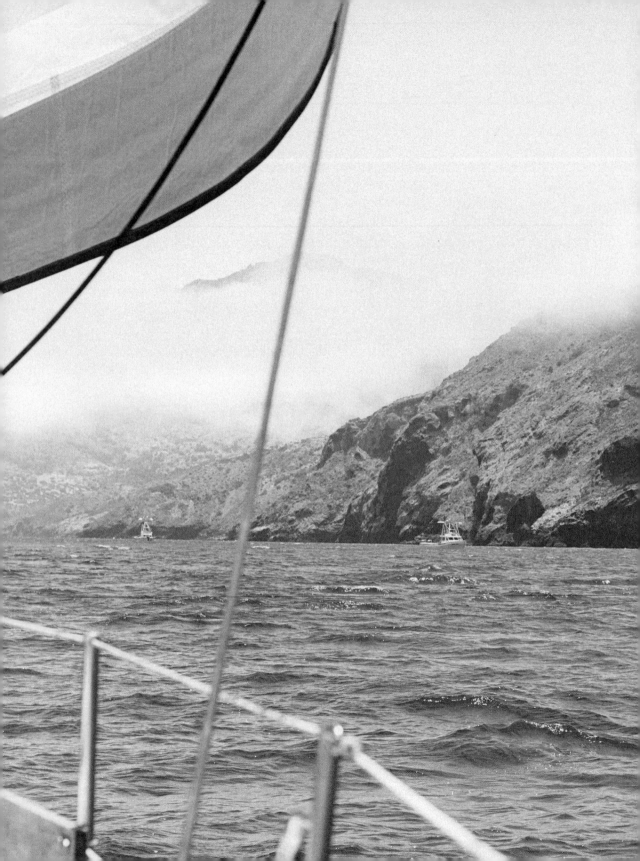

CHAPTER 7

BOATS

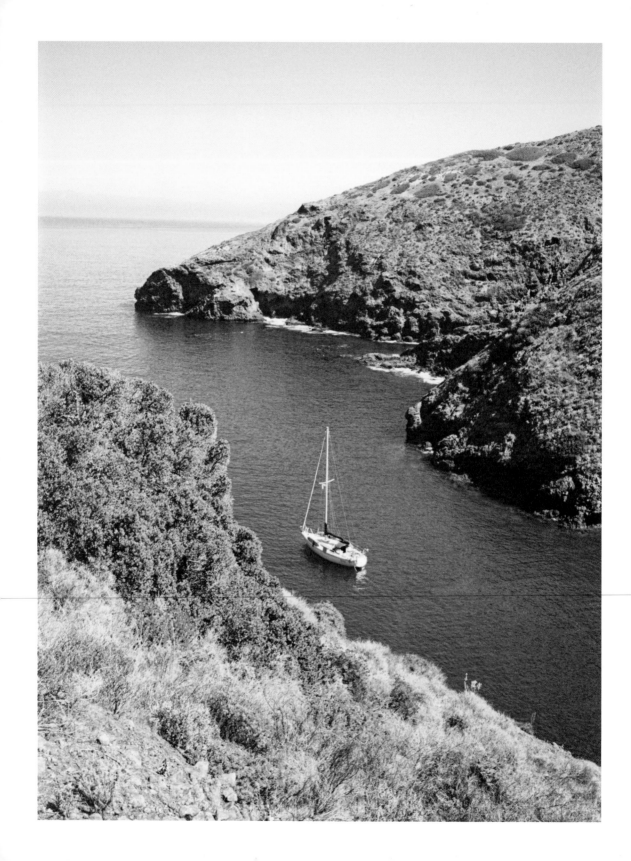

Trevor and Maddie Gordon's Sailboat Home and Escape Pod

Trevor and Maddie Gordon live in and around Santa Barbara, California, on their 36-foot sailboat, *Brisa*. Trevor is a professional surfer and Maddie manages a surf shop.

We've lived on our boat for about four and a half years now. When we first got word we were going to be evicted from our house, we started to consider it as an option. Trevor had spent a lot of time on boats as a kid and it made a lot of sense financially.

At first it was a difficult transition. We went from living on really amazing properties with trees and chickens and all of that. It's a lot to give up—having animals, being able to go for a walk in the morning and pick fruit for breakfast. But on the other hand, you get to sail around and fish and live in something you own. It's a bounty in a different way.

We were looking for boats for a long time before we found the perfect one. The *Brisa* was built in '87 in Long Beach. It came straight to Santa Barbara and it's been in the same slip in the same marina ever since. It's a 36-foot Catalina, a style of boat that was mostly designed

for families to go out cruising around the Channel Islands. Since the Islands are only about 25 to 50 miles offshore, Catalinas compromise a little bit of performance for extra comfort. They easily sleep a family of four, and can sleep up to six if everyone is willing to get a little snug. They are great for sailing—very smooth and easy to operate—but also have a lot of comfortable space. That makes them great to live in full-time, especially compared to more traditional cruising yachts.

True cruising yachts are designed for holding large amounts of food, fresh water, and fuel. You lose a ton of room when you start storing all that. Our boat holds about 75 or 80 gallons of water and 33 gallons of fuel. That's plenty for us. A boat that's designed for more serious long-distance sailing will typically have a 300- or 400-gallon water storage tank and another 150-gallon tank for fuel. That takes up a lot of hull space.

We live in the harbor and use the bathroom and shower there. We try to take the boat out sailing to the islands once every couple of weeks. Usually we go for a night or two, but sometimes we're there for a week or more. Traveling by sail has a very three-dimensional feel to it. You don't just follow a road, you set a heading and cruise. When you leave the shore behind and see nothing but horizon, that's a very special feeling you only get on a boat. That's what sets it apart from living on the land.

Sometimes when you're docked in the marina for weeks, you can forget that you're living on a boat at all. A marina is its own community that is very different from any community on land. In some ways it's a lot like a trailer park. But it's very nice. It's quiet. The sound of the sea drowns out the sound of the road. It's definitely part of the city, but it is very much on the fringe. It takes a bit of effort to get down here. You have to drive all the way through town and then park, and then it takes ten minutes to walk out the dock to our slip. It's a challenge when you have to carry a lot of stuff, like your groceries, all the way down to the boat.

When we first got the boat, we replaced some of the lines and hardware, but almost everything else is original. The interior we have hardly changed at all. They put so much effort into designing boats that everything just works.

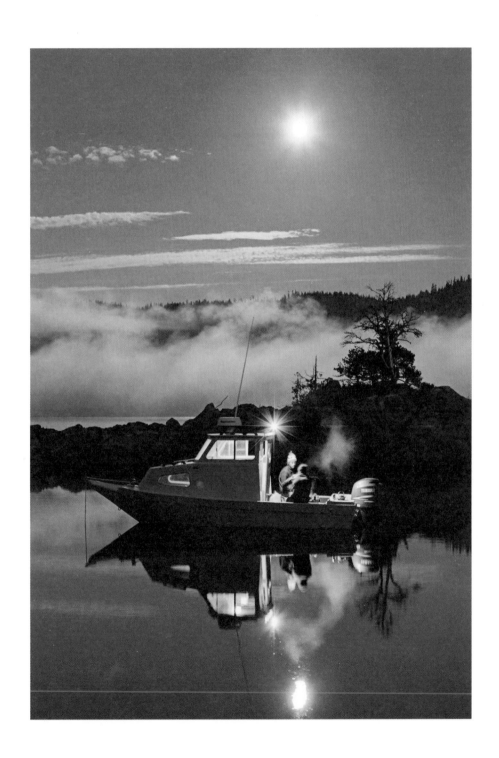

Mold is a constant threat. We run a heater all the time, even when it's warm out. Keeping the interior dry is really important when you live on a boat full-time. The backs of the cupboards are particularly prone to mold, so every once in a while we do a big purge and deep clean. Every month we have the bottom of the boat cleaned by a service in the harbor. We keep covers on the sails and all the lines to protect them from UV damage. So there's a lot of upkeep, and it's very different from what you have to do to maintain a house.

You meet a lot of cool people sailing. It's a totally different world. Usually, they're always moving. They're in that mind-set where anything is possible: "Oh, I don't know where we're going. We'll be in Mexico for a couple months and then, I don't know, maybe the Galapagos from there." It's just really laid back. You can lay anchor almost anywhere in

the world and just hang out, really get a feel for a place. People will go over to Tahiti and fly back for a month to make some money, then head back out there and just keep moving.

One thing that's special about owning a boat is the amount of freedom you have. If you have a water maker and solar power or a wind generator, you can go anywhere. Except for food, you're completely self-sufficient.

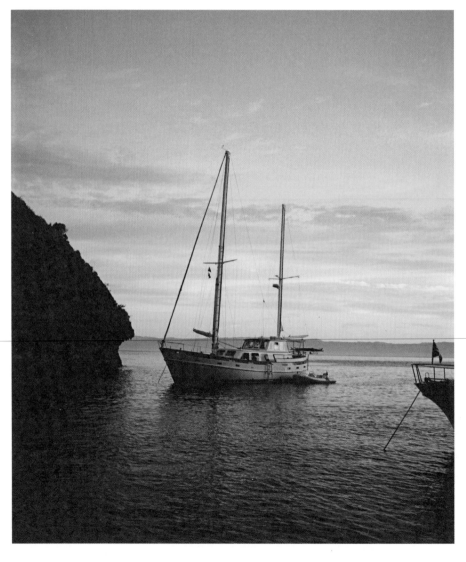

BOATS
ARCHIVE

Andrew Tomayko | *Mounika (Silent Girl)* | Ocean Park, Washington

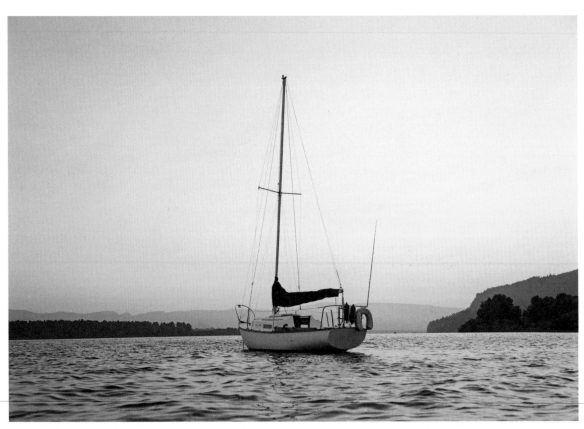

Andrew Tomayko | *Mounika (Silent Girl)* | Ocean Park, Washington

Gabriella Palko | *Zephyr* | Valdez, Alaska

Trevor Gordon | Catalina Island, California

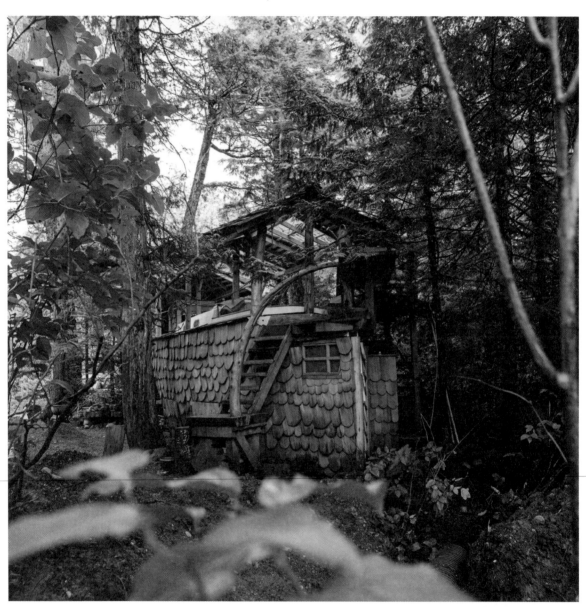

Shane Hilder and Tia Soby | *The Landboat* | West Coast of Vancouver Island British Columbia, Canada

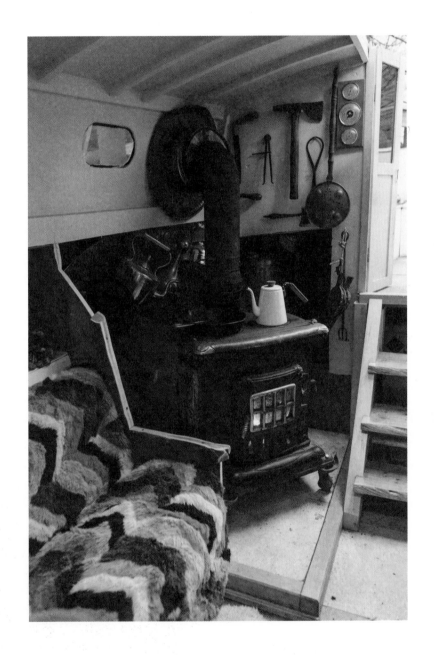

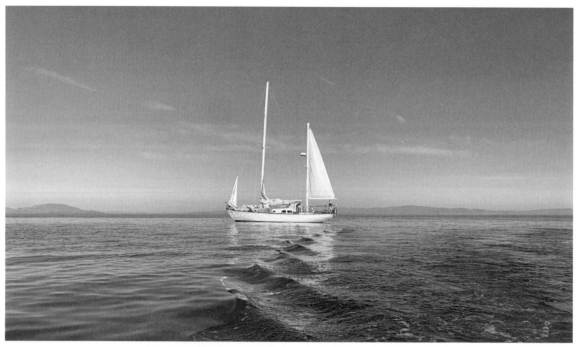

Craig Murli | San Francisco, California

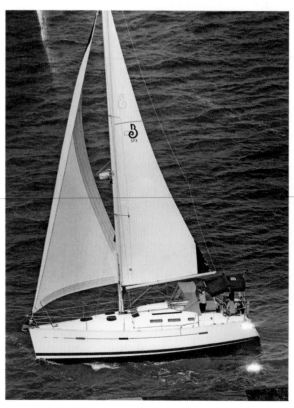

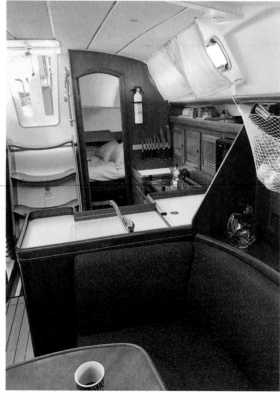

Chase and Chelsea Eckert | *Esprit* | New Orleans, Louisiana

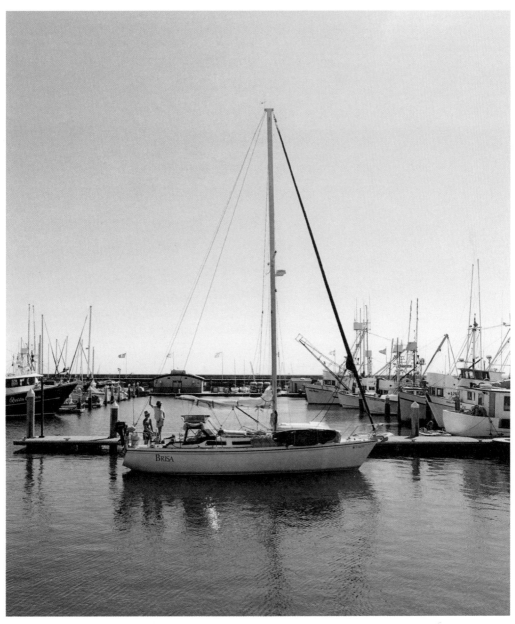

Foster Huntington | *Brisa* | Santa Barbara, California

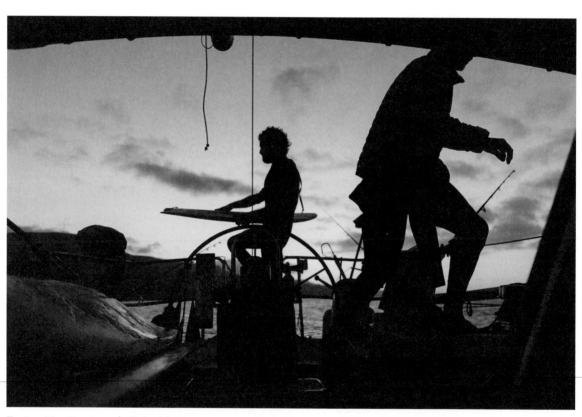

Foster Huntington | Baja, Mexico

CHAPTER 8
VEHICLES

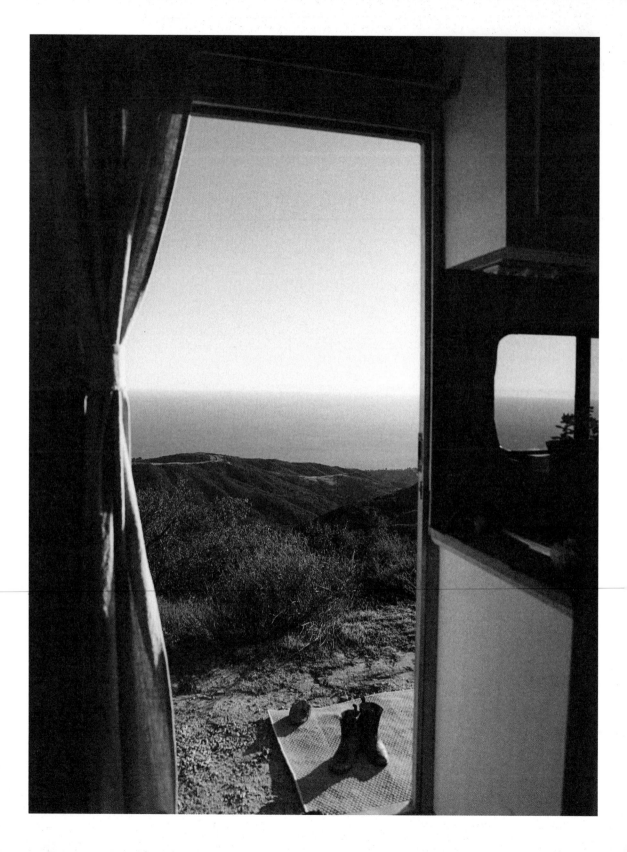

Aniela Gottwald's Trailer Home for Horses and Adventures

2020

Aniela Gottwald lives wherever her 40-foot horse trailer, the Mothership, is parked. She is currently working on a film documenting her latest adventure, a 4,000-mile journey from Canada to Mexico completed with three wild mustangs and a dog. She is the founder of the educational nonprofit Riding Wild.

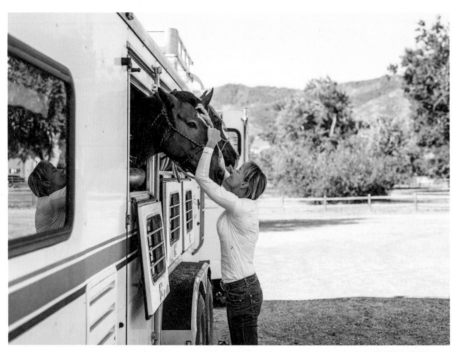

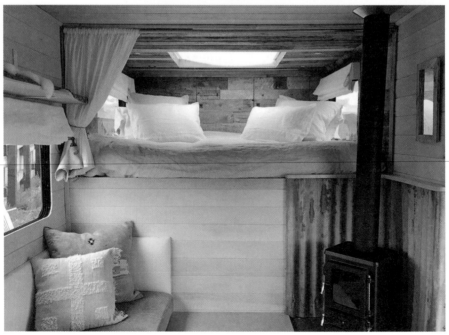

My mom and I wanted to find a trailer that she could live in while I'm on expedition rides. She's my support team when I'm out on the trail, so we needed something that she could stay in and take out to remote places for my resupplies. We found an old 2002 Sundowner and we decided it would be perfect to renovate and make into a home. My mom is an interior designer and my dad was an architect. They worked as a team to create sustainable eco-conscious homes before he passed away, so design and building skills run deep in our family. My dad always wanted me to be a designer because I really love making spaces—spaces that are not only special and unique for the person living in them, but are also sacred in some way.

So we bought the Sundowner, gutted it out, and started scrounging for materials. We used salvage timber from a hundred-year-old barn in Wisconsin. We put in a stone slab and some rustic metal and a little hobbit stove. Our goal was to make the interior feel like a little cabin with Scandinavian roots. I'm Scandinavian and I really like that light birch-wood aesthetic associated with traditional Scandinavian design. It ended up working out really well, and the Mothership was born.

The trailer itself is around 40 feet. I tow it with my 2014 Dodge Ram 3500 with a Cummins diesel engine. The thing is a beast. It can take the Mothership anywhere. When I'm on an expedition, my mom often has to meet me for resupplies at really remote trailheads that are hard for vehicles to get to. So we have had to take the Mothership over some really difficult terrain—washed-out roads, riverbeds, all that. We really push it to the limit, but we've always made it. The Mothership itself is a little scratched up, especially along the sides, just because it's easy to forget how big it is. When I have my horses on board, the whole thing is around the size of a semi.

When I go on an expedition, I usually take two trailers since I need at least two riding horses for myself, another riding horse for support personnel, a backup riding horse in case of injury, and a few mules for packing. The Mothership itself can hold three horses. Whenever we stop the Mothership and set up camp, we take the horses out and keep them in portable corrals. They are pretty lightweight and the horses can knock them over, but they usually know better and respect the boundary.

A few years ago I did the Arizona and Colorado trails—in total about 1,300 miles of riding. My mom was in the Mothership supporting me the whole time and she loved it. It's really nice to know that any time I come off the trail, I get to take a shower and rest in a nice space. It's really been an amazing part of our expedition life.

When we're not on expedition, I'm usually living in the Mothership myself. When I first moved across the country five years ago from my home in Massachusetts, I actually put a bed in my Prius and lived in that. I made curtains that fit all the windows in the back so no one could look in on my space. I could lie down really comfortably when I put the seats down. I lived in my Prius for quite a while. I even used to go off-roading in it, which I probably shouldn't have done since it has no undercarriage.

That was my first taste of living on the road. Once I finally started living in the Mothership, it was like going from a one-room studio in New York to a big penthouse in the countryside somewhere. It was a really nice upgrade.

I'm currently working on a film about horse-packing, which I feel is very closely tied to how we have developed as humans throughout history. We have always worked side by side with animals. It is an ancient bond, something that is in our blood, deeply a part of ourselves. It's how we were first able to discover, explore, and settle so much of the world. My goal is to use film to help people reconnect with that feeling. It is my belief that, by doing so, we can help to rebalance the world—not just the many ecosystems that are being drastically affected by climate change, but also our psychology.

ecosystems + Psychology damaged by climate ▷

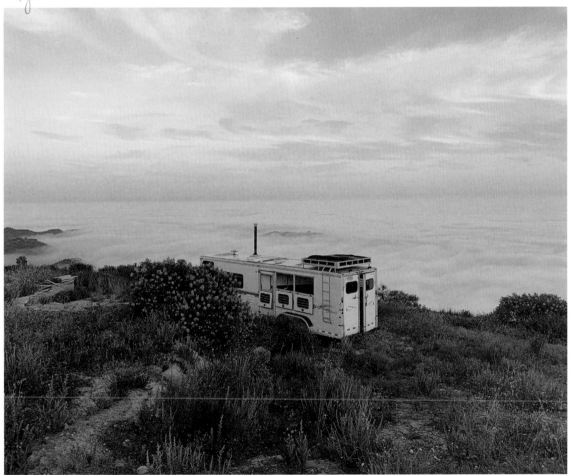

I feel so lucky to be adaptable and get to move around. It really fuels my spirit. I guess I'm just naturally nomadic. So many of our ancestors moved around with the seasons. As a species, we really haven't lived fully settled lives for very long. It's an amazing feeling to be able to call the whole world, or at least the whole country, my home. It has broken down my concept of home as a stationary place and helped me reconnect with a sense of freedom. For me, home is not a place. It is my relationship with my mom when we're on an expedition together. It is having my horse by my side, whether we're on the highway or together on the trail. That, to me, is home.

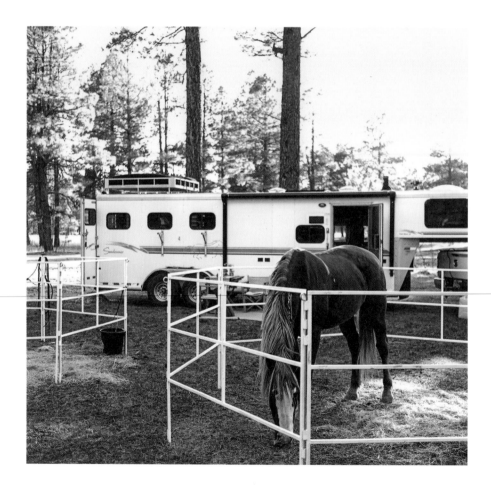

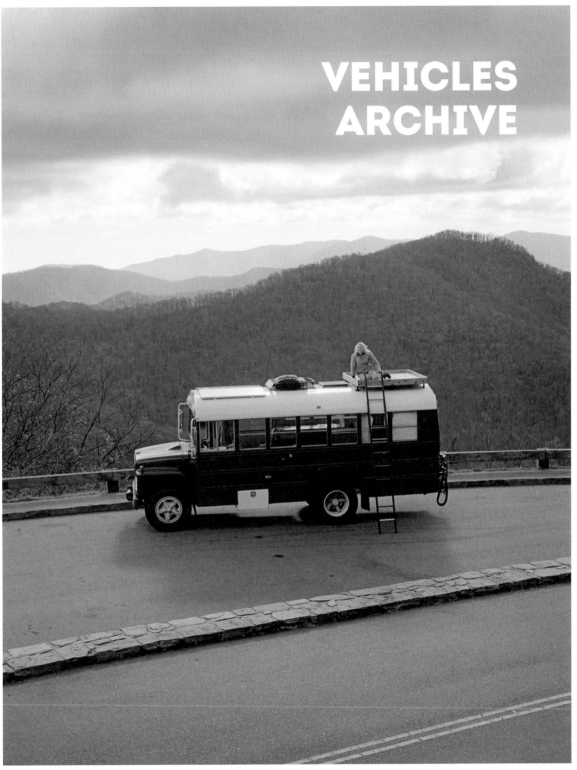

VEHICLES ARCHIVE

Spencer Hoffman | *Betty* | Ojai, California

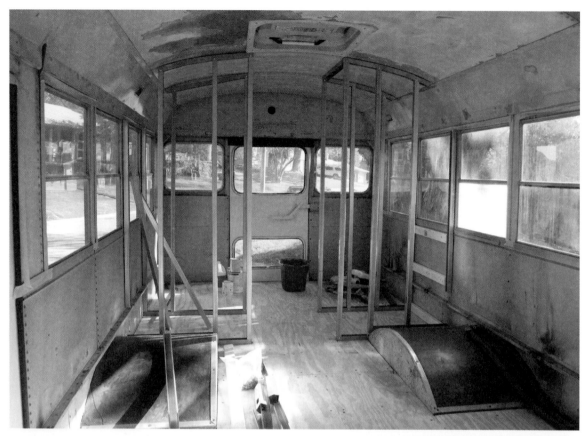

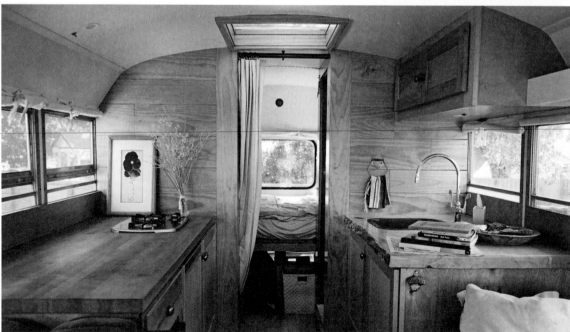

Spencer Hoffman | *Betty* | Ojai, California

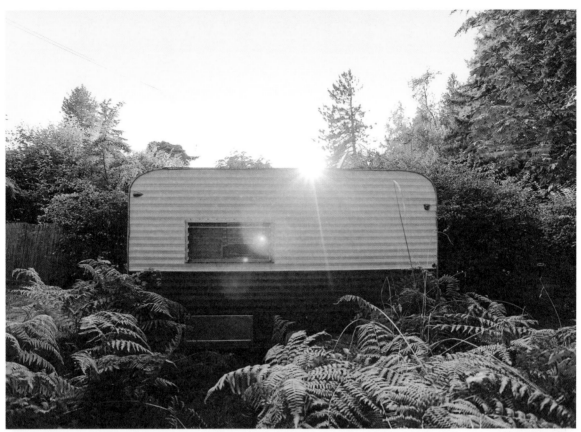

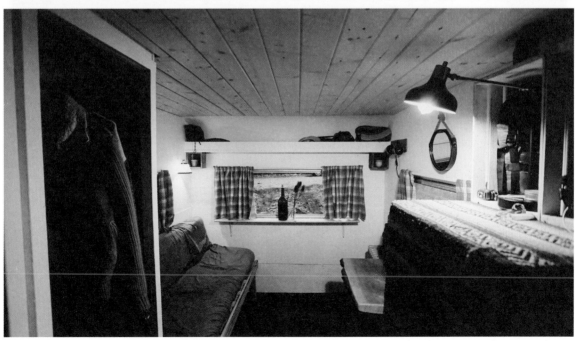

Roan Hardman | *Shasta Trailer* | Eatonville, Washington

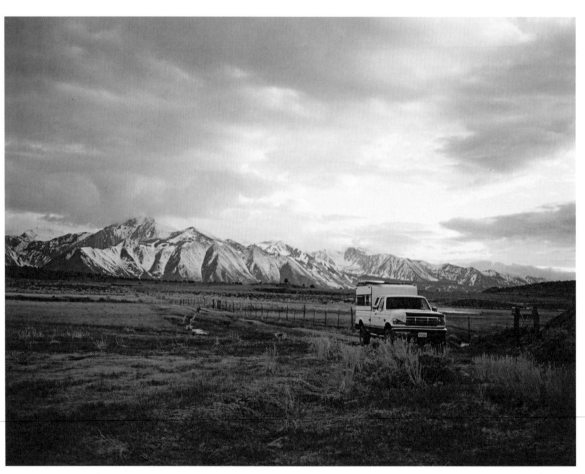

Trevor Gordon | Eastern Sierras, California

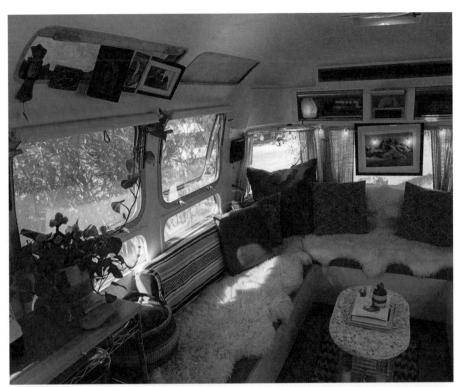

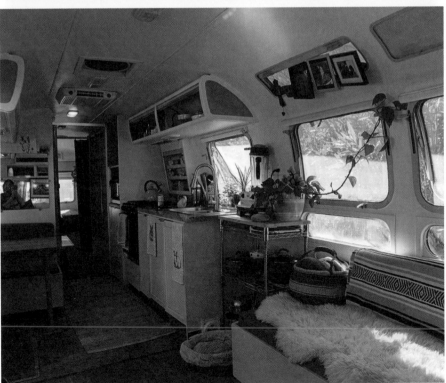

Whitney Bell | Santa Cruz, California

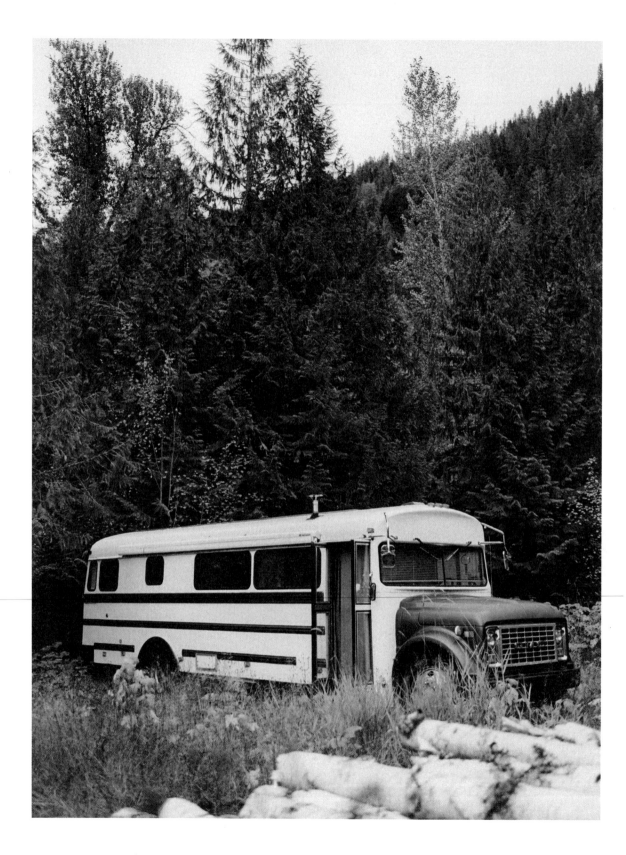

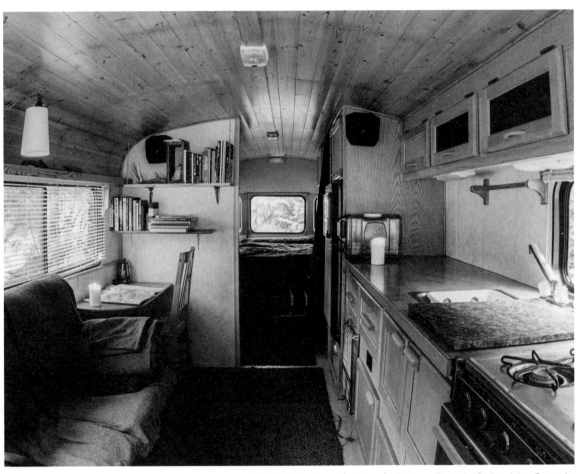

Tristan Kodors | *Elly* | Salmo, British Columbia, Canada

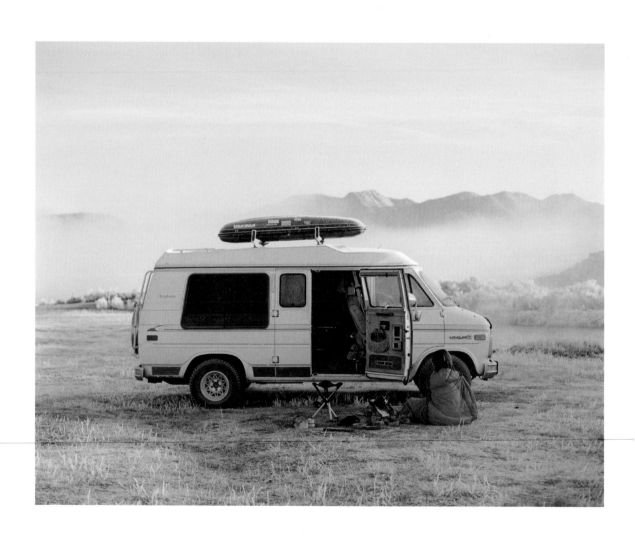

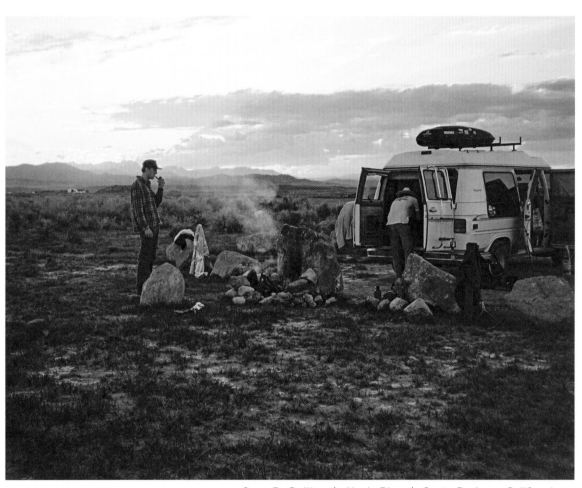

Sean R. Collier | *Uncle Rico* | Santa Barbara, California

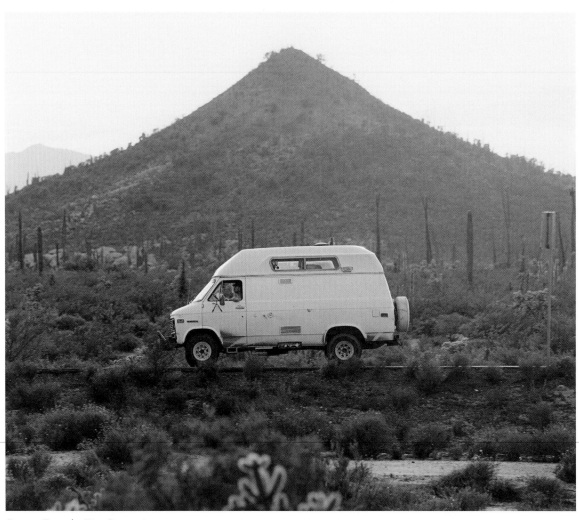

Bryan Fox | *The General*

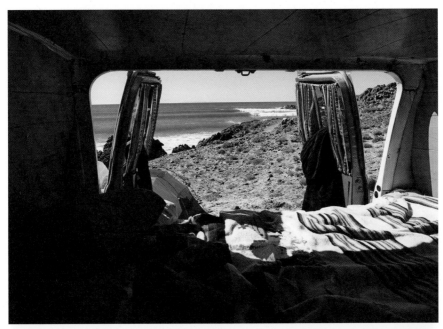

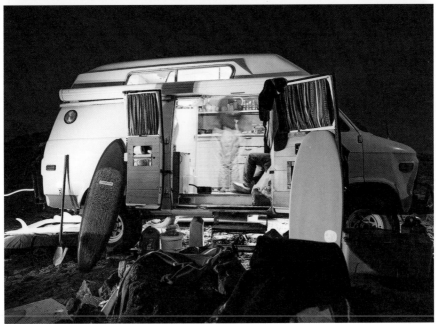

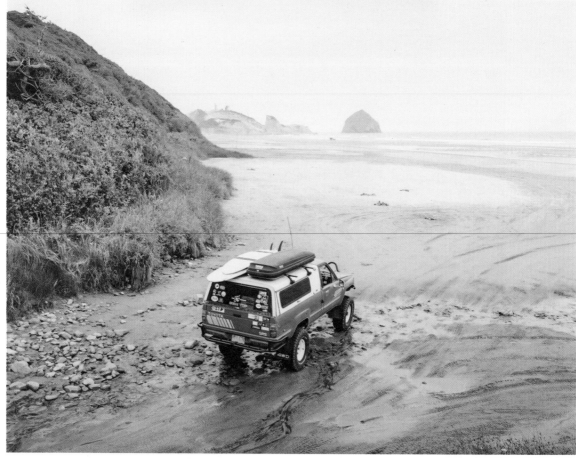

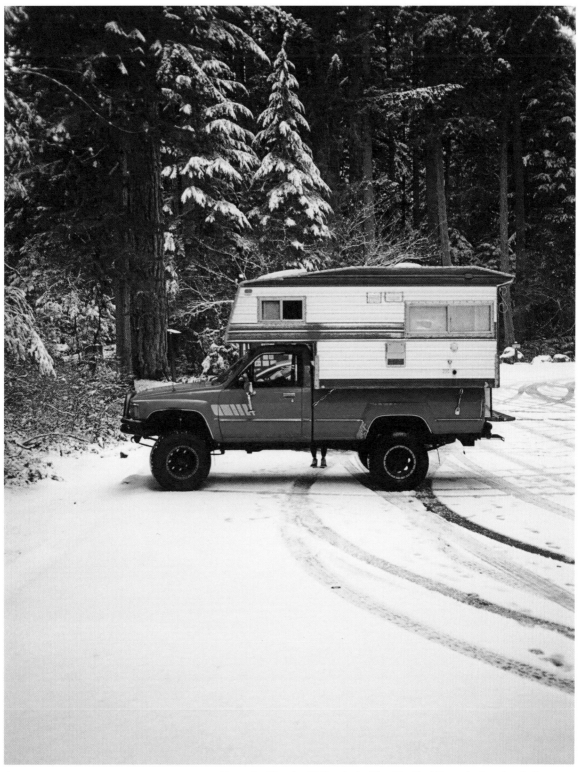

Nate Duffy | *Clifford aka The Big Red Dog* | Portland, Oregon

Austin Smith

Spencer Wilkerson | *Herald* | Northern California

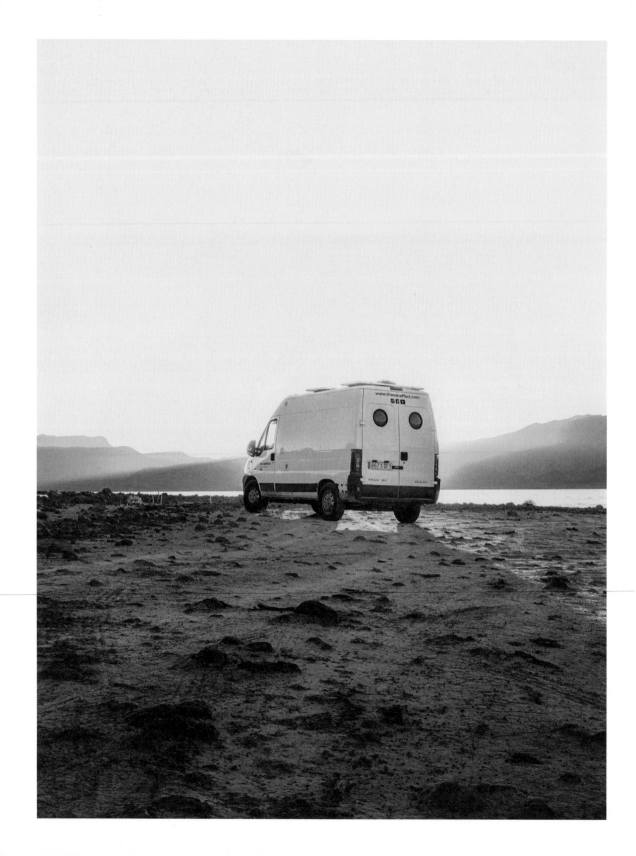

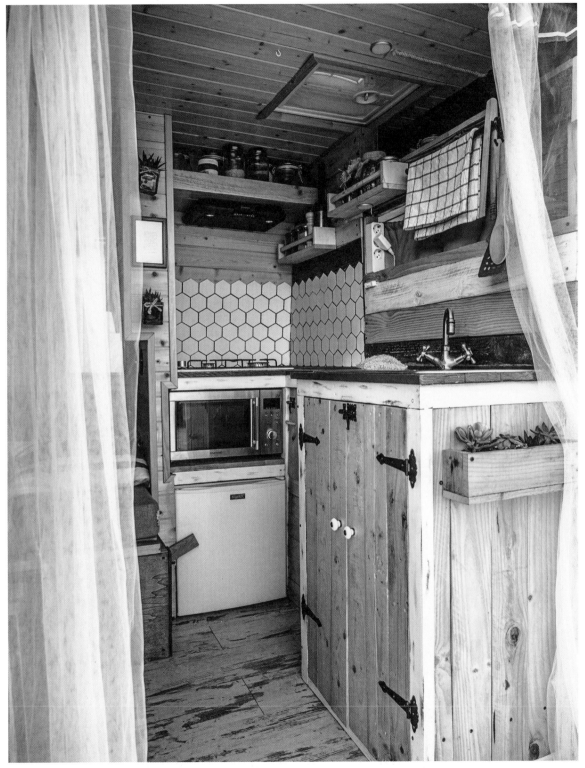

Aitor and Laia | *Peugeot Boxer L2H2* | Catalonia, Spain

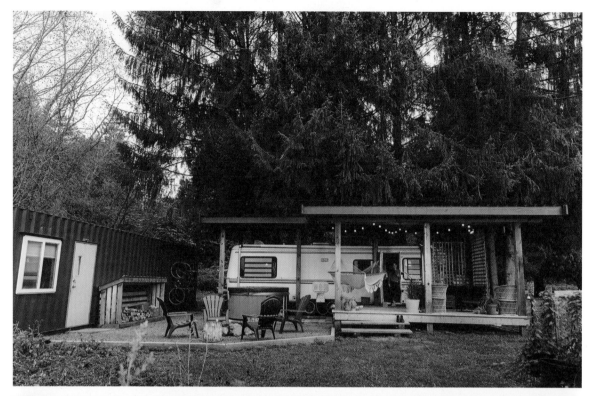

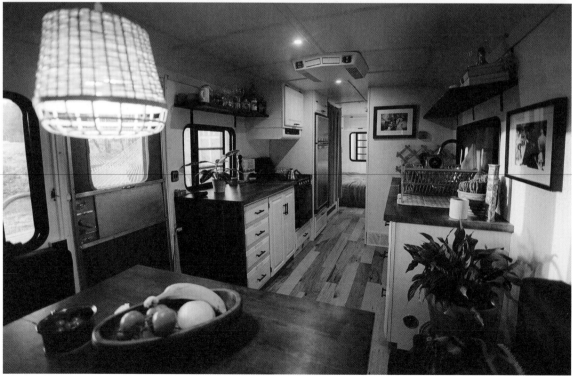

Dawson and Bonnie Friesen | *Argosy the Airstream* | Yarrow, Chilliwack, British Columbia, Canada

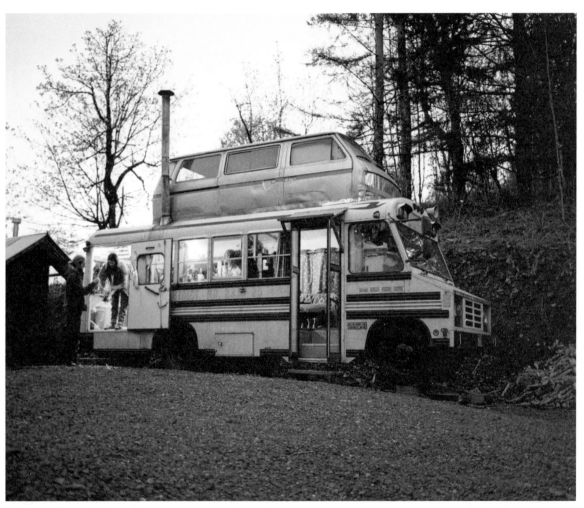

Spencer Wilkerson | Washington State

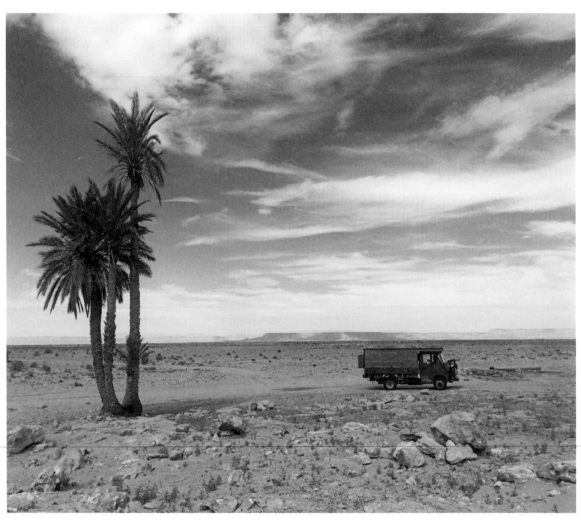

Philipp Sacher | *Mercedes 608 Walküre* | Germany

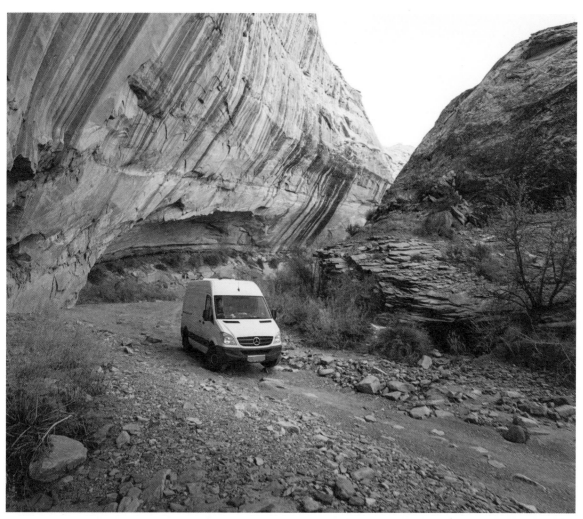

Spencer Wilkerson | Northern California

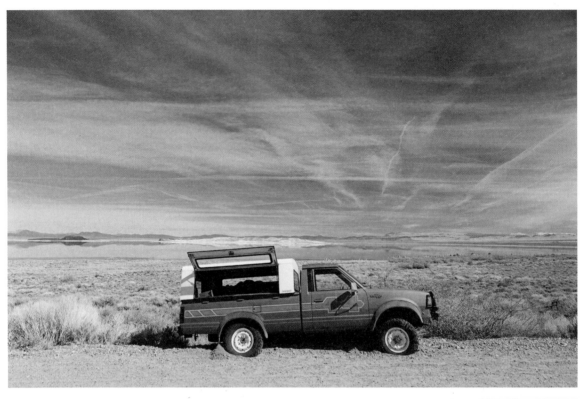
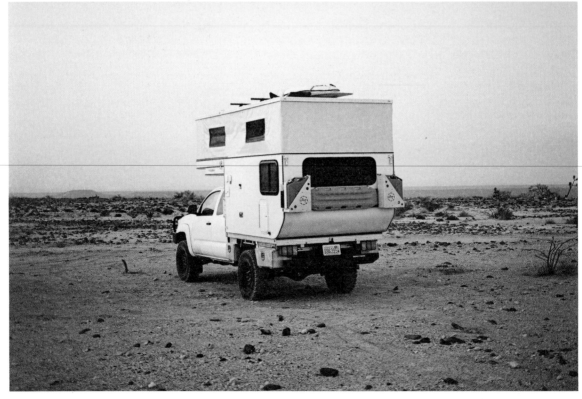

Vehicles I Have Known and Loved with Foster Huntington

The first vehicle I lived in was a 1987 VW Vanagon Syncro. They're really popular vans because they have a capable four-wheel drive system and a lot of room to live in and store gear while keeping a short overall length. When I was looking into vans, I knew that I wanted four-wheel drive because I thought at the time that I wanted to spend time in the snow and also go to places like Mexico and Central America that have less-developed infrastructures. The Syncro seemed like a really cool option. The problem is they're highly sought after. At the time I was looking, there really weren't many good options for four-wheel drive vans. Plus, only a few thousand of the Syncros were ever imported to the United States. That's really driven up their value and there's a big subculture of people interested in them.

There are things about Syncros that I love. The model I had is called a Weekender, which means it had a fold-down bed, but didn't have any of the fancier add-ons that came standard in Westfalias. For me, as a single guy in my mid-twenties, that was actually a really good option. There are a lot of things that are antiquated about the Westfalia interior—specifically the refrigerator, which is a propane/electric hybrid. Those things suck. They never work. And they take up a lot of space in the front. I knew I didn't really want to cook that much in my van. You do that a couple of times and everything you own ends up smelling like what you cooked. So I actually preferred to just cook outside and have that extra space in my van.

I installed a little storage box and put some storage racks on the top for clothes and wetsuits and surfboards and stuff like that. I also put in a power inverter and a new sound system. One thing that's really nice

about Vanagons is they have tons of windows. The visibility is amazing. When you're camping, though, that can be kind of problematic, because people can see right into your space. So I got a tint in Watsonville, California, from this Mexican body shop. They just whipped on a super dark limo tint. That was pretty much everything I changed.

After living in my Vanagon for a year and a half and being plagued by constant car problems, I started looking for the most reliable vehicle I could possibly find. I got the idea in my head that I wanted to have a pickup truck with a flatbed. I had been looking at a bunch of photos of these Australian campers, where they would take a small pickup truck—a Nissan Patrol or a Toyota Hilux or something like that—and then convert it to a flatbed and put a pop-top camper in the bed. The appeal is that you have a super reliable car that's really capable off-road, and it comes with a nice living space. I had this fantasy of creating an expedition vehicle that I would drive all around the world. I wanted to do the Pan-American Highway, all that kind of thing.

It's really easy to get carried away when you start dreaming about this stuff. I was reading all kinds of expedition and adventure forums and I decided that I needed all this crazy gear—two extra tires, an engine snorkel, a winch, all that. I got very much into the gear-head mind-set. I ended up spending a ton of money having this custom truck built. Once again, it looked great on paper. I got a six-speed manual, a nice light camper, an extended fuel tank, a winch, everything. The guy that I had build it convinced me that it would all work. And then it ended up being 1,500 pounds over the gross weight. When I went to turn a corner too quickly, it would pick up on three wheels. I had to buy bigger brakes because the truck was just too heavy for the stock brakes to handle. I also burned through a clutch at 40,000 miles. It just couldn't handle the extra load. It turns out that a truck that performs really well off-road with 500 pounds in it drives like a minivan when it's lugging around 2,500 pounds. And in the end, I never needed the snorkel or any of my fancy add-ons. So I ended up selling the truck and taking a step back from the whole vehicle game.

Once you know the freedom afforded by a vehicle that you can live in, it will always be in the back of your mind. It wasn't long before

I started to feel like I wanted to get out on the road again. But I didn't want to get in over my head on another expensive and impractical-to-build vehicle. So I started experimenting with cheaper options. I bought an Aerostar for a thousand bucks. I didn't love that, so I sold it and bought a Nissan pickup for twelve hundred. I found a metal canopy on Craigslist, threw a plywood platform in the back for my mattress, and cruised around in that. I had that thing for three years and it treated me really well. It was capable off-road, it was comfortable to sleep in, I could store a bunch of camping gear and surfing equipment in it. After going from these expensive, tricked-out dream vehicles to basically

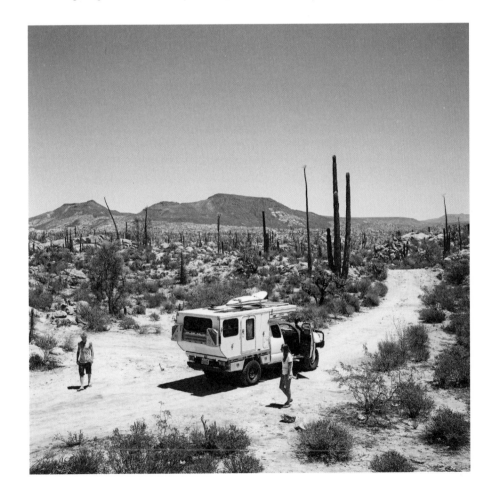

living in cheap beaters, I realized it just didn't make that much of a difference to me. I was just as happy in my Nissan as I was in my super custom flatbed build. And it was a lot nicer to drive.

Now I have a Dodge Sprinter 118. My daily driver is a Honda CR-V, and my Sprinter is the same length, which is pretty amazing. Sprinters have been on my radar for a long time. They're two-wheel drive, but they're great vans. When I decided I needed another good road trip vehicle, I started scouring Craigslist all over the country. Within a few weeks I'd found one in Phoenix that looked perfect. I called the guy, put down a deposit, flew down there with a one-way ticket, and drove it back up. I couldn't be happier with it. I can park in a normal parking spot. It's a high-top, so I can stand and walk around in it. And it gets 28 miles per gallon. To me, I think it's hands down the best van for living in. It's what I was always looking for. They're tall enough that you have some comfortable space. They look like a work van, so you can really get away with sleeping on the street in cities. They have great ground clearance. I've driven mine on some pretty gnarly roads and never had any problems. Best of all, they aren't that expensive—for older ones, that is.

My advice to someone who is really interested in getting a vehicle to live in would be to not get their head stuck in the clouds like I did. There's the idea of what you want from the car and then there's the reality of how you'll actually be using it. You may think that you're going to be in the Australian outback rock-crawling and blasting through rivers, but the reality is, that isn't very likely. Or you might go down to Mexico and get somewhere really remote. You'll drive out somewhere crazy and think, "Wow, thank God I have this car," and then some local will cruise by in a Honda Civic or a Dodge Neon, and there you'll be looking like a dork in your Kilimanjaro approach vehicle.

But no matter what you get, traveling around in a car is something special. It's all about having a sense of freedom. You can wake up one place and take your home with you to another place. That's a beautiful thing. It sounds really obvious just to hear it, but once you start experiencing it—once you have that feeling of waking up in Nevada and thinking, "Maybe I'll go to Big Sur, or maybe I'll go to the Olympic Peninsula," and knowing that you can just do it—you'll realize how much that type

of freedom really means. It's a feeling of autonomy and self-reliance that is completely missing from our culture. Every time I go on a road trip, even if it's only for a few days, I reconnect with that.

I live in a home now. I never intended to live in a car forever. But it was an incredibly important part of my life. When I think back on those days, I often remember a Mark Twain quote: "Travel is fatal to prejudice, bigotry, and narrow-mindedness." And it's true. I think everybody should try living in a car if they have the opportunity, at least for a few months. It's a life-changing experience.

ACKNOWLEDGMENTS

I would like to thank Jake Winchester for compiling the interviews and making them fit into the book. Randy Martin wrangled hundreds of photo submissions and tracked down releases and information.

I would like to thank Lloyd Khan for inspiring myself, my family, and millions of people around the world to think differently about structures and dwellings.

In addition to so many other things, I learned to build from my mother, Stephanie Huntington. As a kid, we lived in houses she built and, without her inspiration and help as an adult, I would never be living in a treehouse today.

Without meeting Tucker Gorman my freshmen year in college, I would also never be living in a treehouse today. He not only continues to inspire me to this day but is an amazing builder, responsible for the treehouses and so many other things in my life.

I'd also like to thank Lisa Tenaglia, the editor of this book, for being patient with my dyslexic spellings and working with my personal schedule. Without her hard work, this book would never have happened.

I would like to thank my family. Building is something that both strains and builds close relationships. Some of my happiest memories are building various structures with close friends and family.

Lastly, I would like to thank Kaycee and our dog, Gemma. Making anything, whether a house or a book, requires encouragement, support, and love from home.

This book would never have happened without the blood, sweat, and tears of builders that opted out of building a 2.5 bedroom house out of engineered wood and decided to make something unique. Their passion and energy in both building and photographing their spaces created the places and photos you see in this book.

CONTRIBUTORS

Aitor
Hunter Bancroft
Michael Basich
Michael Becker
Annie Beedy
Whitney Bell
Sora Blu
Taylor Bode
Bubbawood
Ryan Cafferky
Sean R. Collier
Rob Cox
Scott Cushman
Nate Duffy
Mackenzie Duncan
Chase and Chelsea
 Eckert
Eagle Eye
Robin Falck
Howard Fenton
Bryan Fox
Dawson and Bonnie
 Friesen
Matthew Furmanski
Michael Garnier
Jon Giffin
Samuel Glazebrook
Trevor and Maddie
 Gordon

Tucker Gorman
Aniela Gottwald
Chris Graham
Carey Quinton Haider
Roan Hardman
Ben Hayes
Brett Higson
Shane Hilder
Spencer Hoffman
Stevie Hudson
Dan Huntington
Isaac Johnston
Amy and Tom Jones
Lloyd Khan
Tristan Kodors
Ann-Tyler and Brian
 Konradi
Django Kroner
Laia
Belinda Liu
Hannah Mettam
Michael Murphy
Jay Nelson
Steven and Hanna
 Nereo
Ryan O'Donnell
Amy O'Hoyt
Mike O'Toole
Ansel Ogle

Stevie Page
Gabriella Palko
Alana Paterson
Joey Pepper
Shea Pollard
Jack Potter
Margarita Prokofyeva
Adam Ram
Michael Reynolds
Paul Risse
Sacha Roy
Philipp Sacher
Harrison Schaeffer
Roman Schnobrich
Tim Gilman Sevcik
Tia Soby
Elaine Sol
Nathan Suitter
Cyrus Sutton
Casey Tane
Andrew Tomayko
Jeremy Tuffli
Jeff Waldman
Spencer Wilkerson
William Winters
Jon Wood

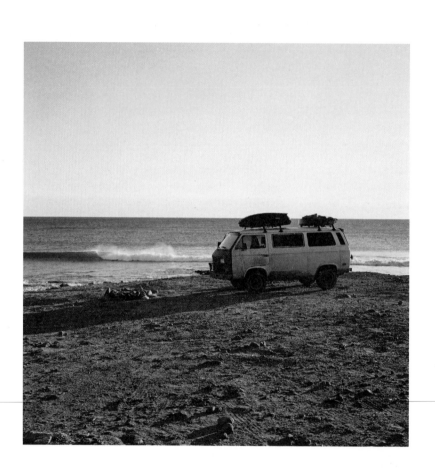